Alberta Hutchinson's
Instant Zen Designs

Racehorse Publishing books may be purchased in bulk at special discounts for sales promotion, corporate gifts, fund-raising, or educational purposes. Special editions can also be created to specifications. For details, contact the Special Sales Department, Skyhorse Publishing, 307 West 36th Street, 11th Floor, New York, NY 10018 or info@skyhorsepublishing.com.

Racehorse Publishing™ is a pending trademark of Skyhorse Publishing, Inc.®, a Delaware corporation.

Visit our website at www.skyhorsepublishing.com.

10 9 8 7 6 5 4 3 2 1

Cover design by Brian Peterson
Cover artwork by Alberta Hutchinson

Print ISBN: 978-1-944686-01-7

Printed in the United States of America

Alberta Hutchinson's
Instant Zen Designs

New York Times Bestselling Artists' Adult Coloring Books

Racehorse Publishing

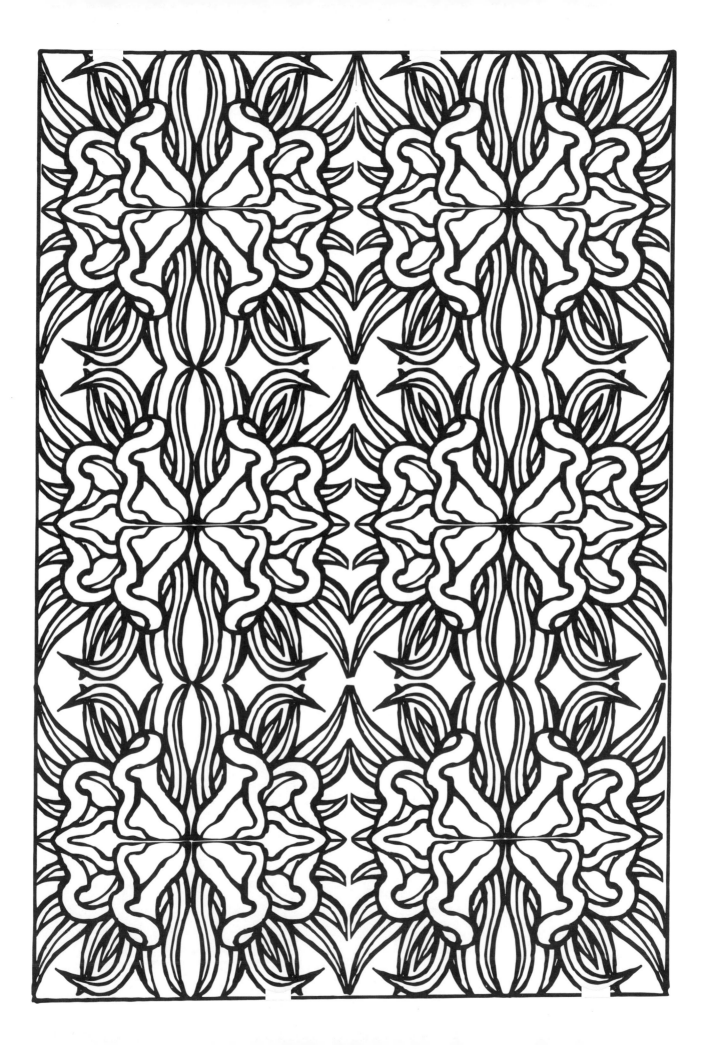

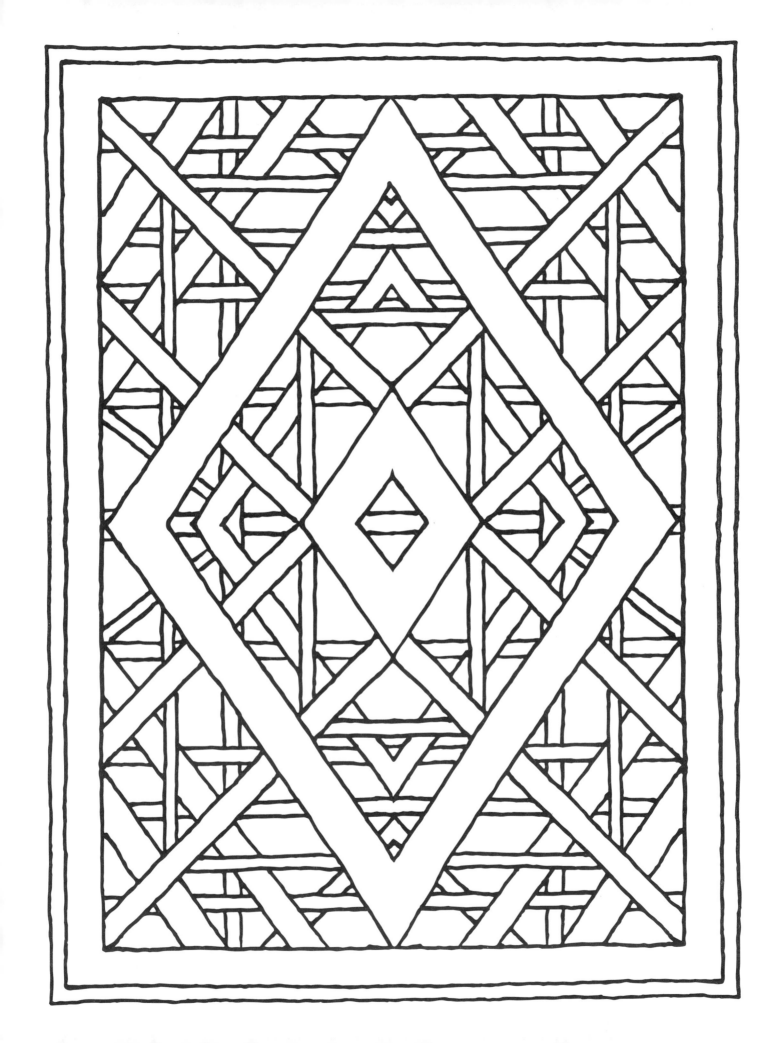

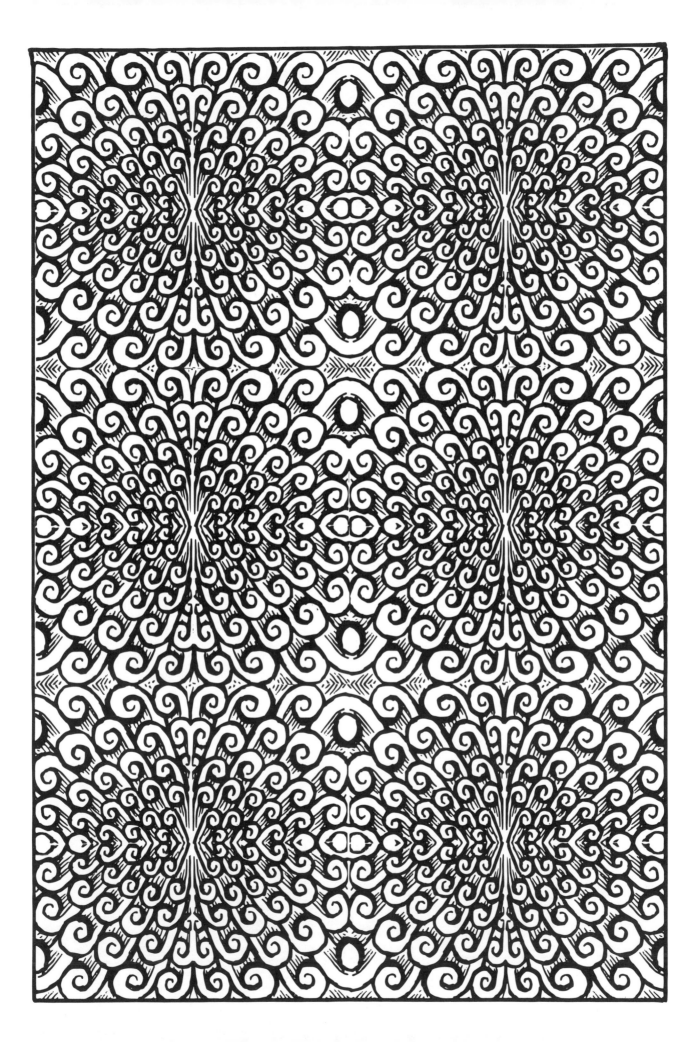

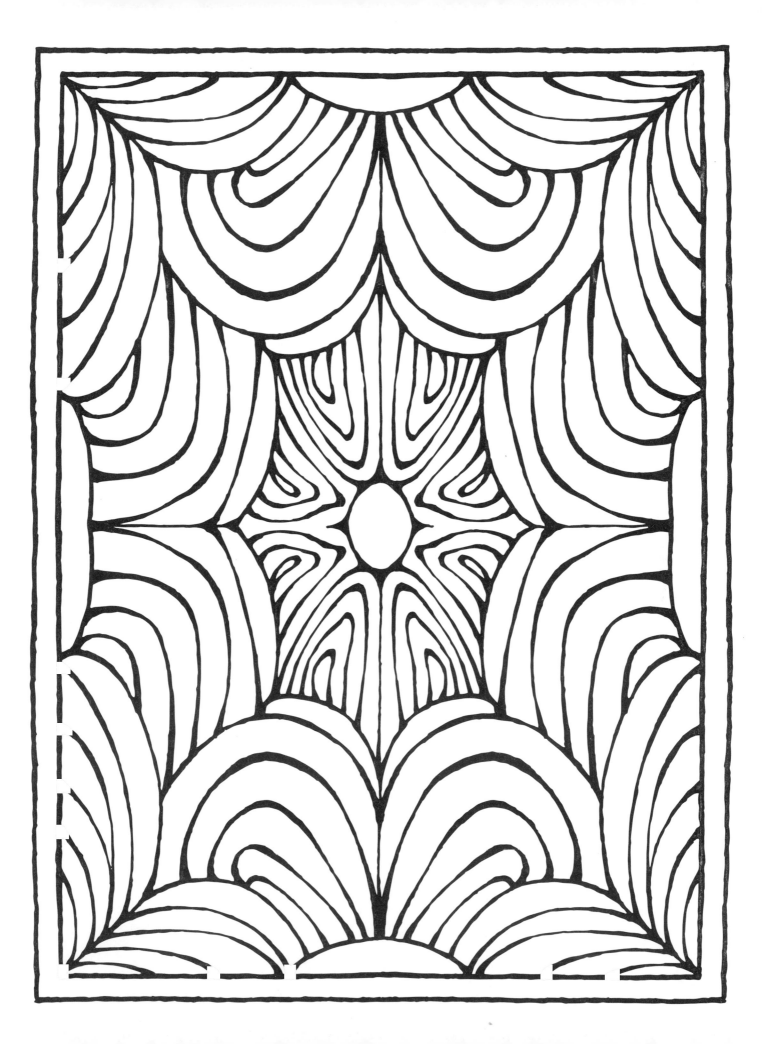

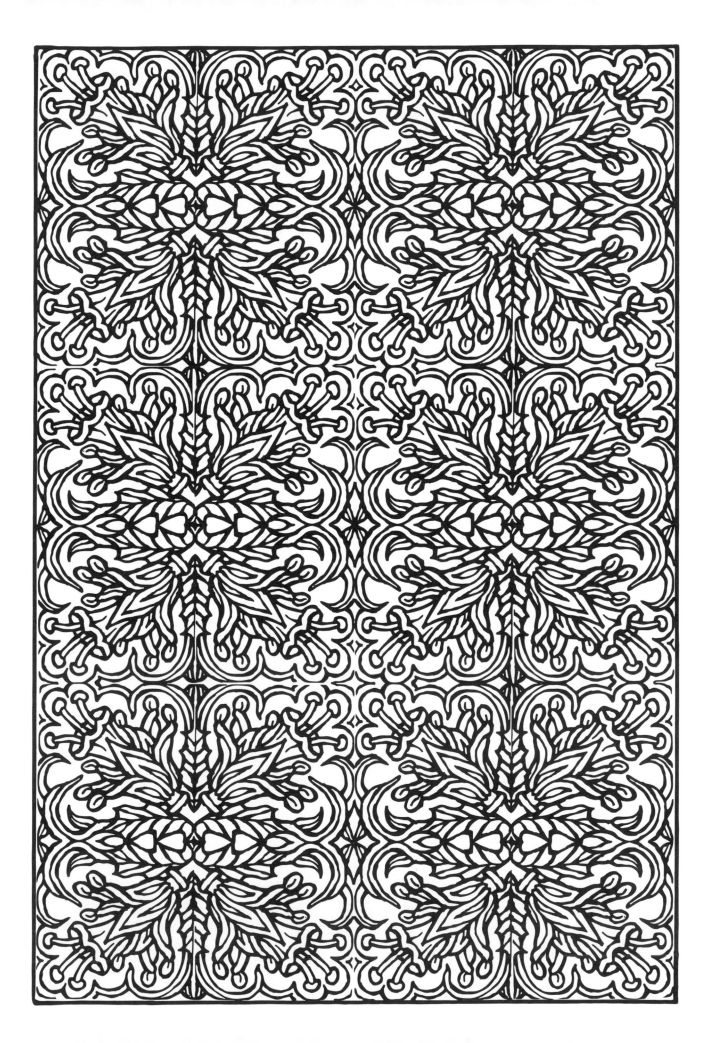

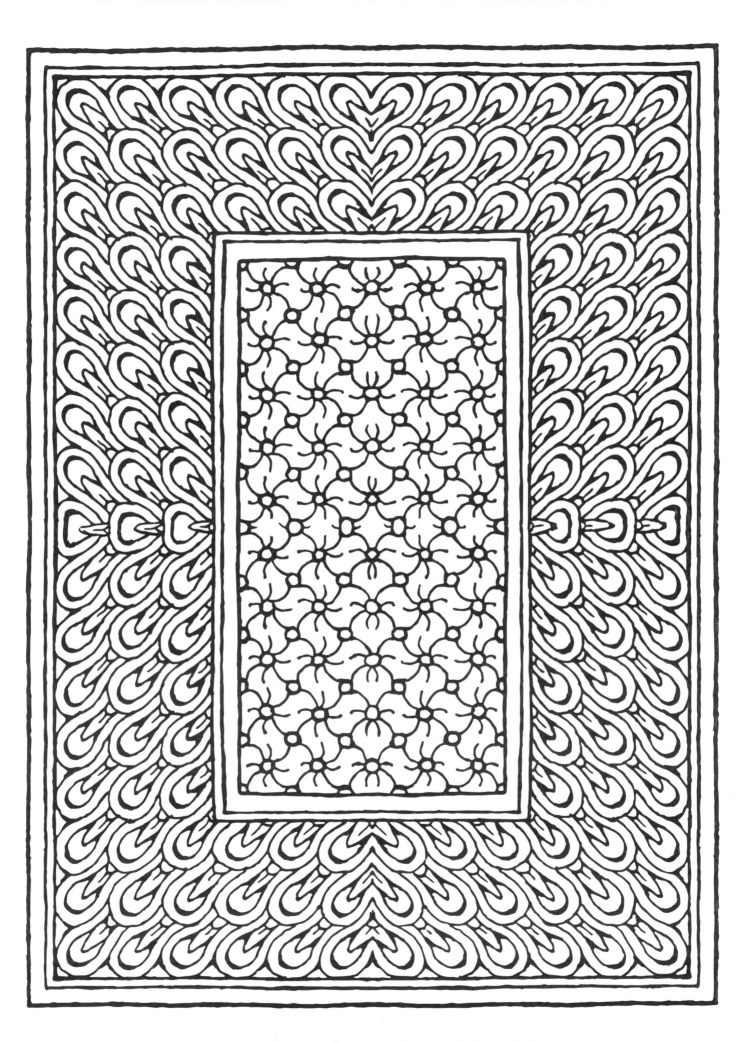

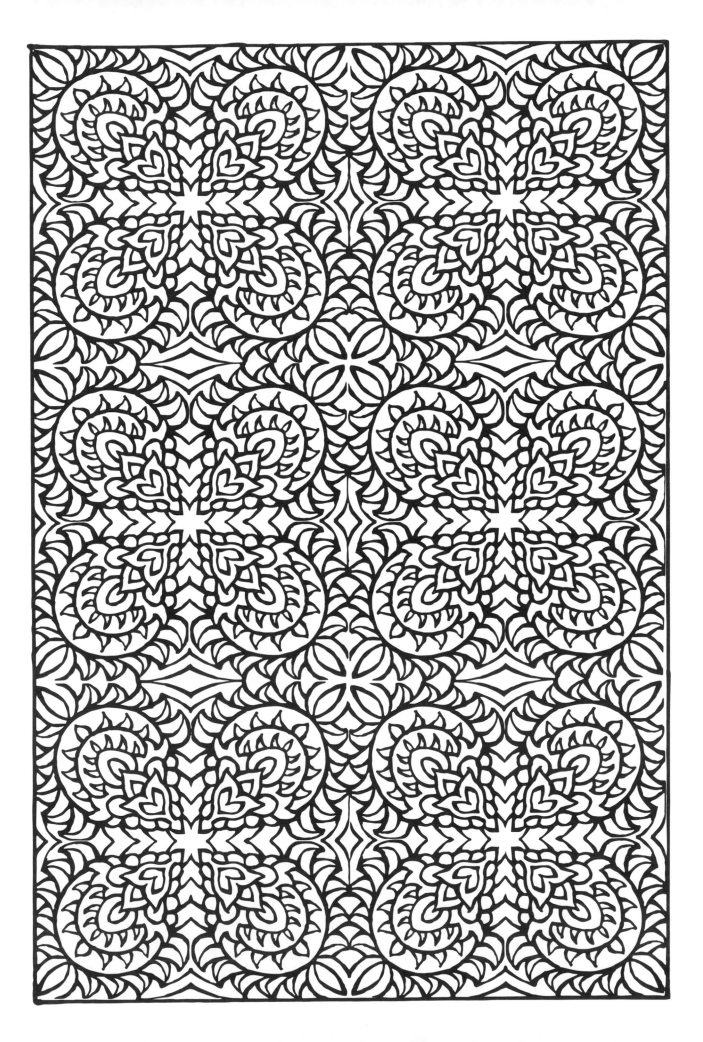

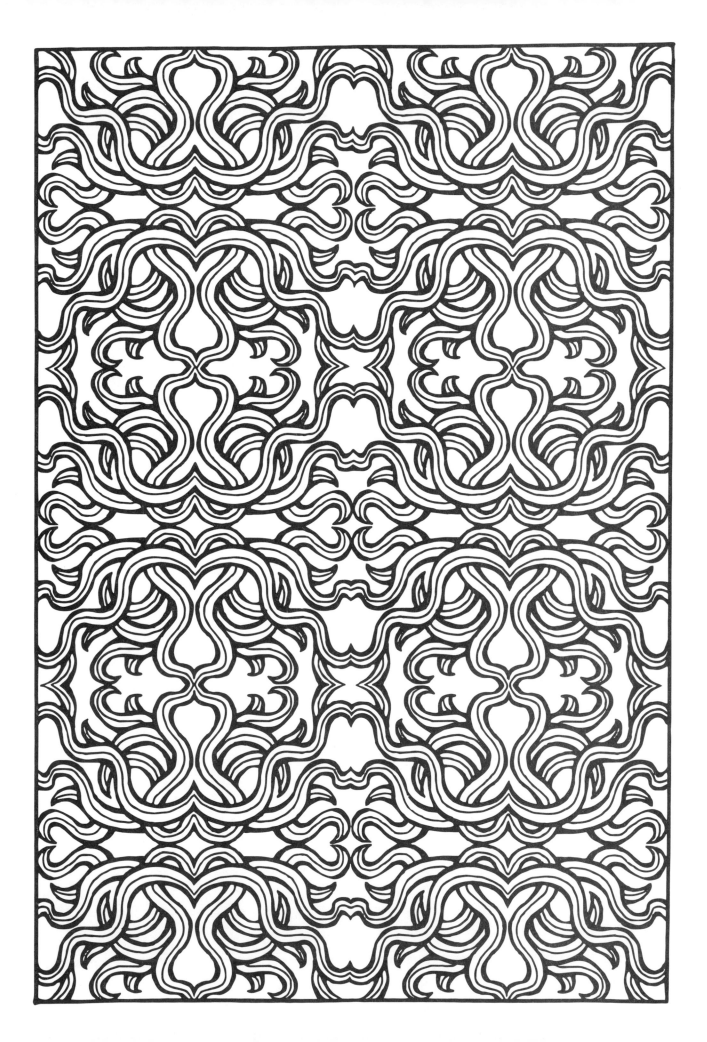

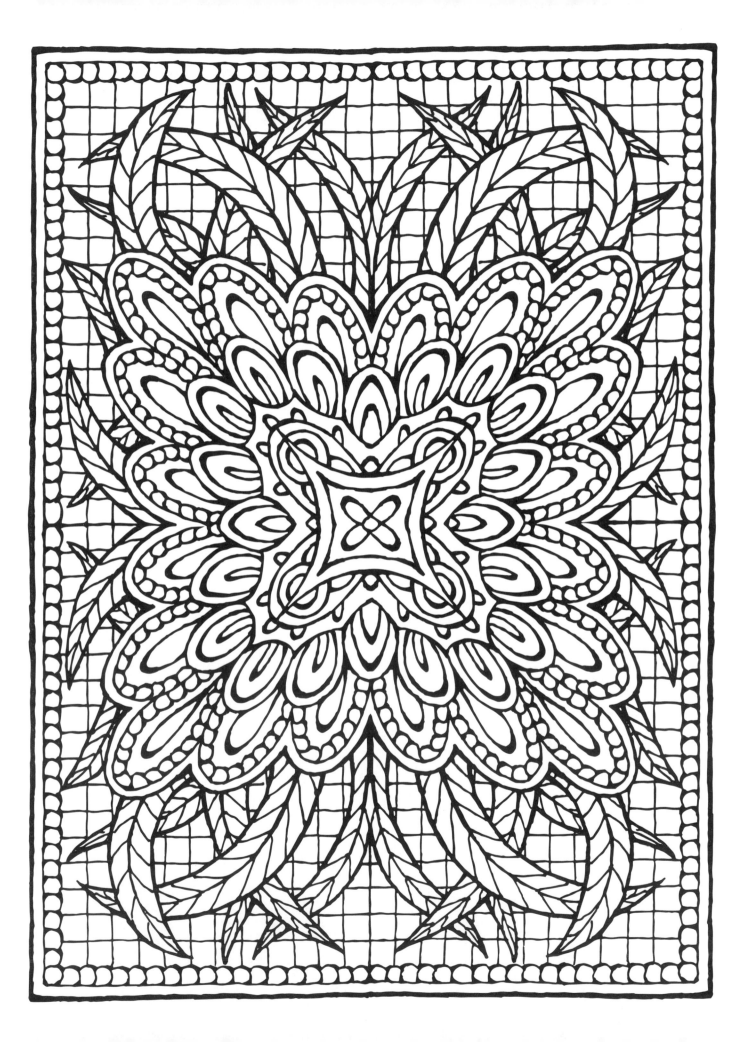

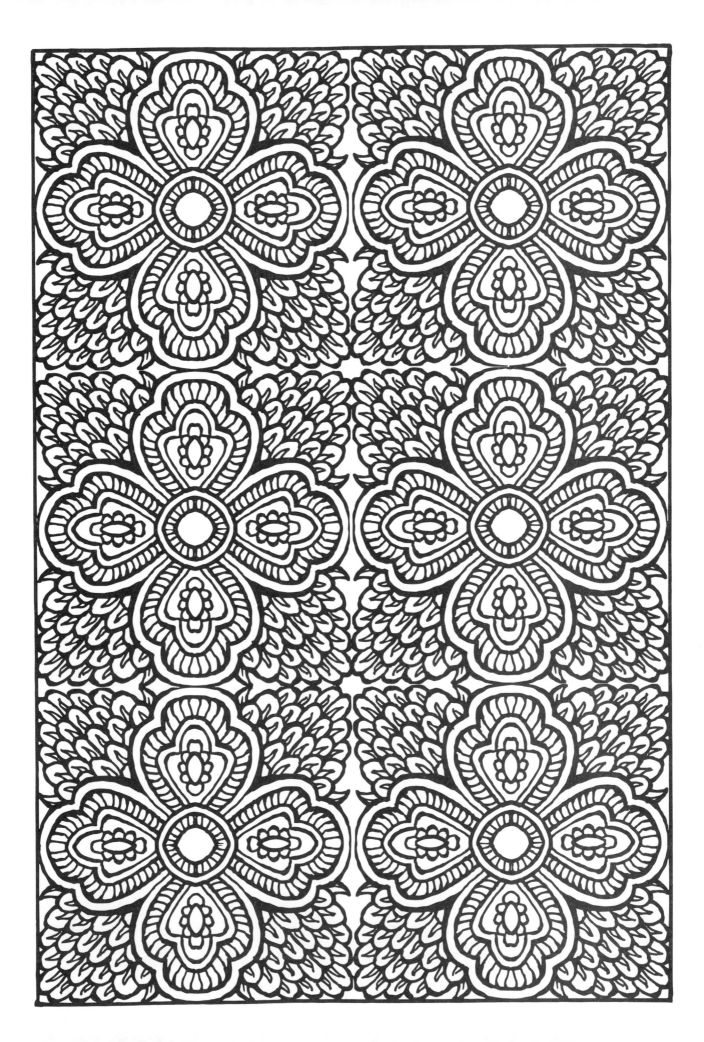

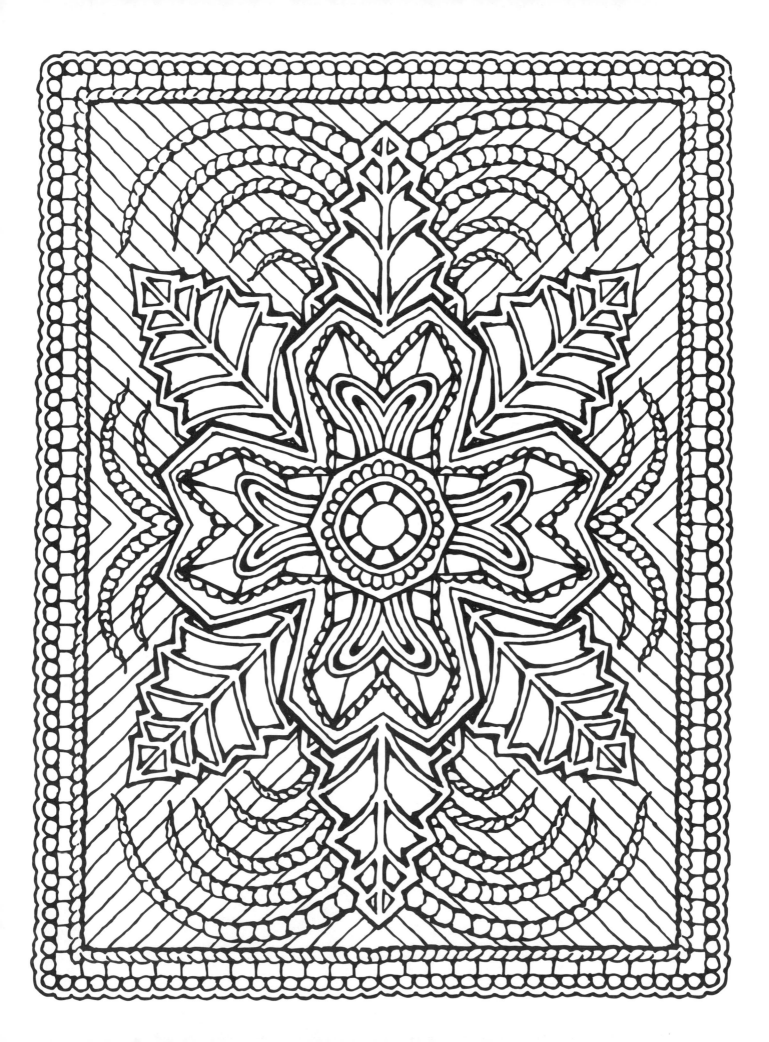

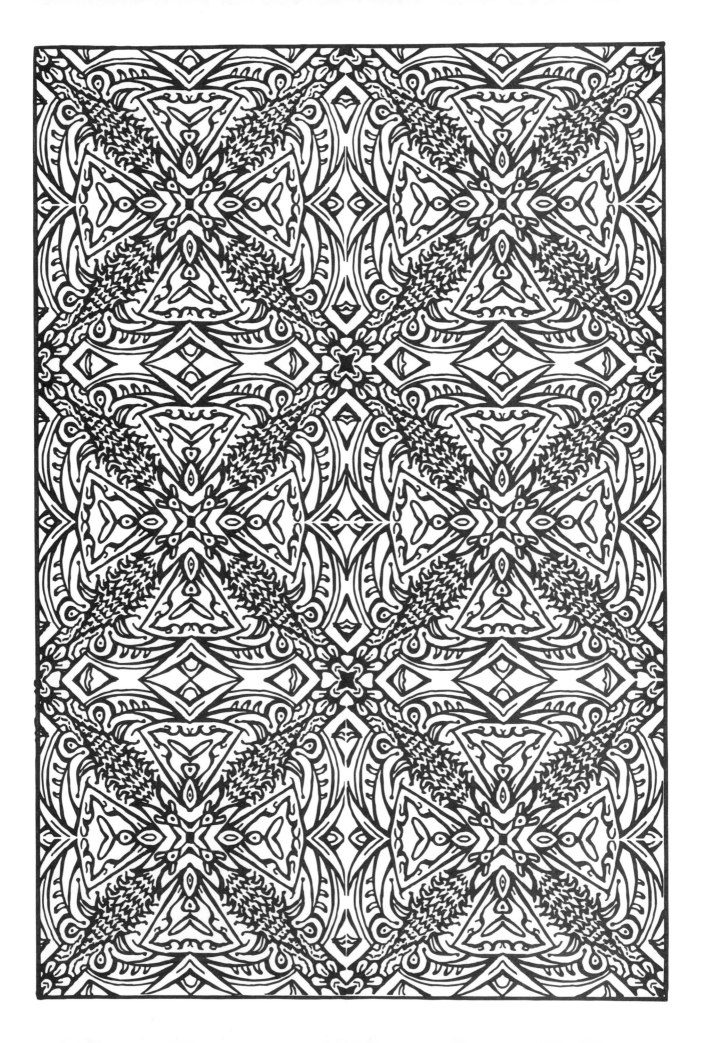

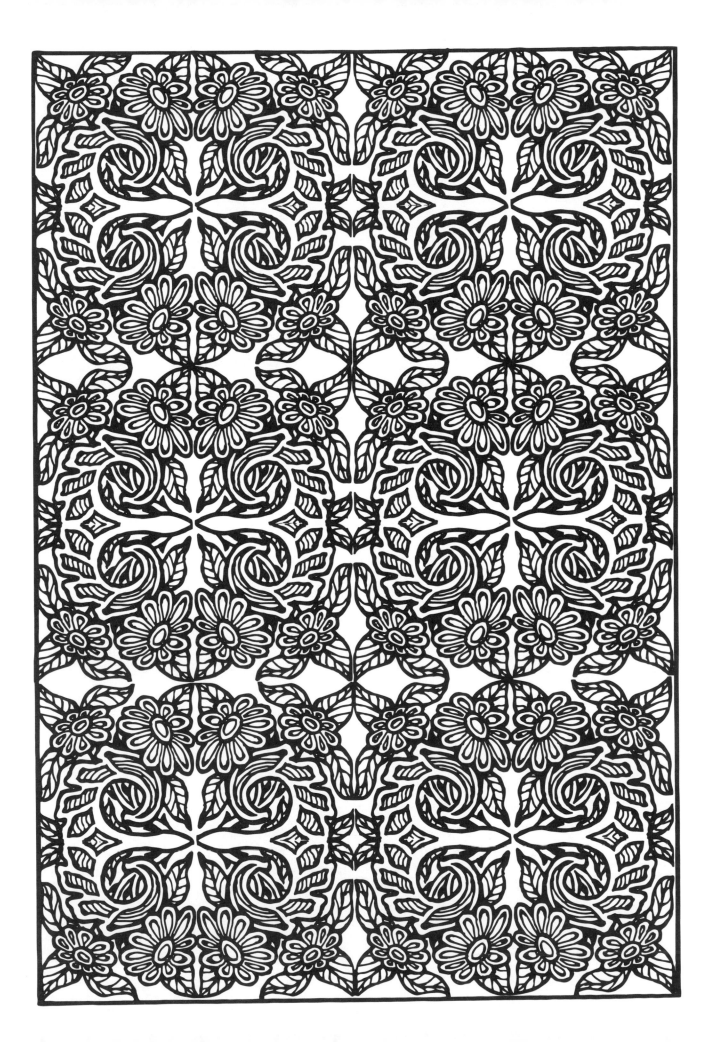

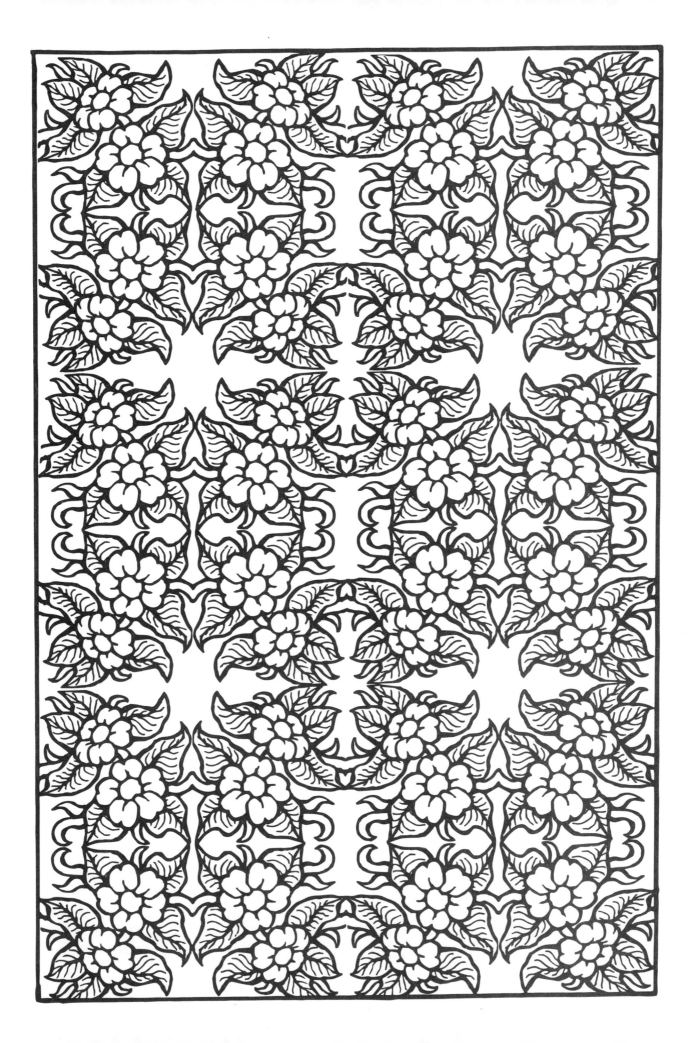

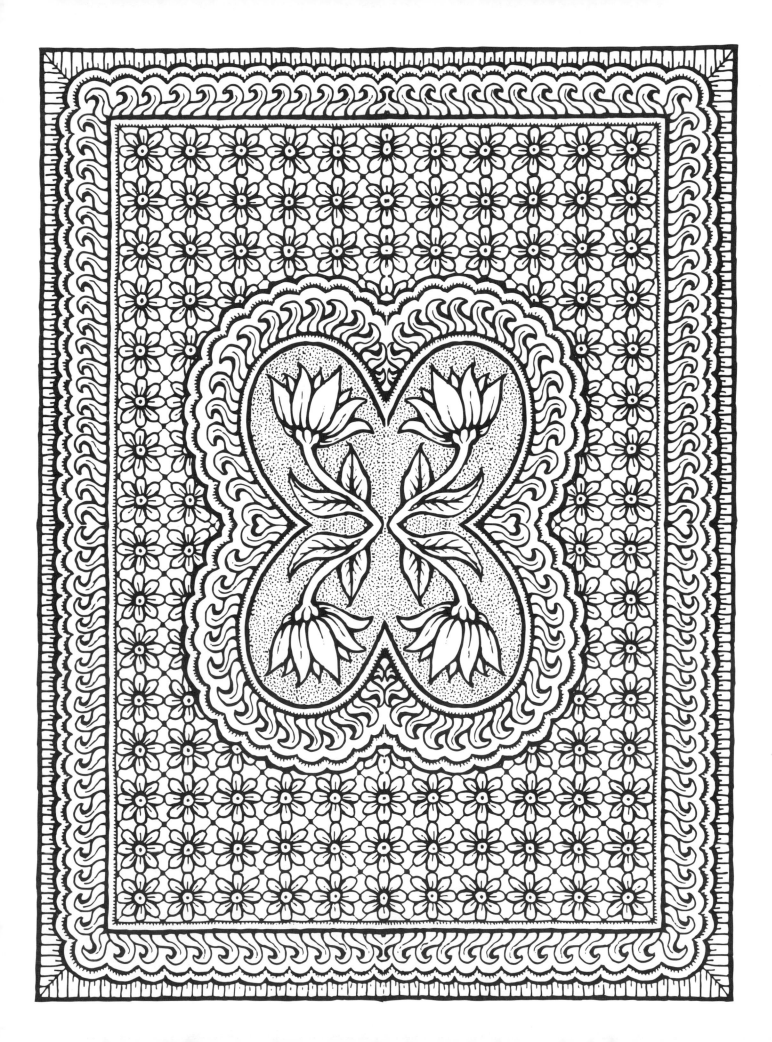

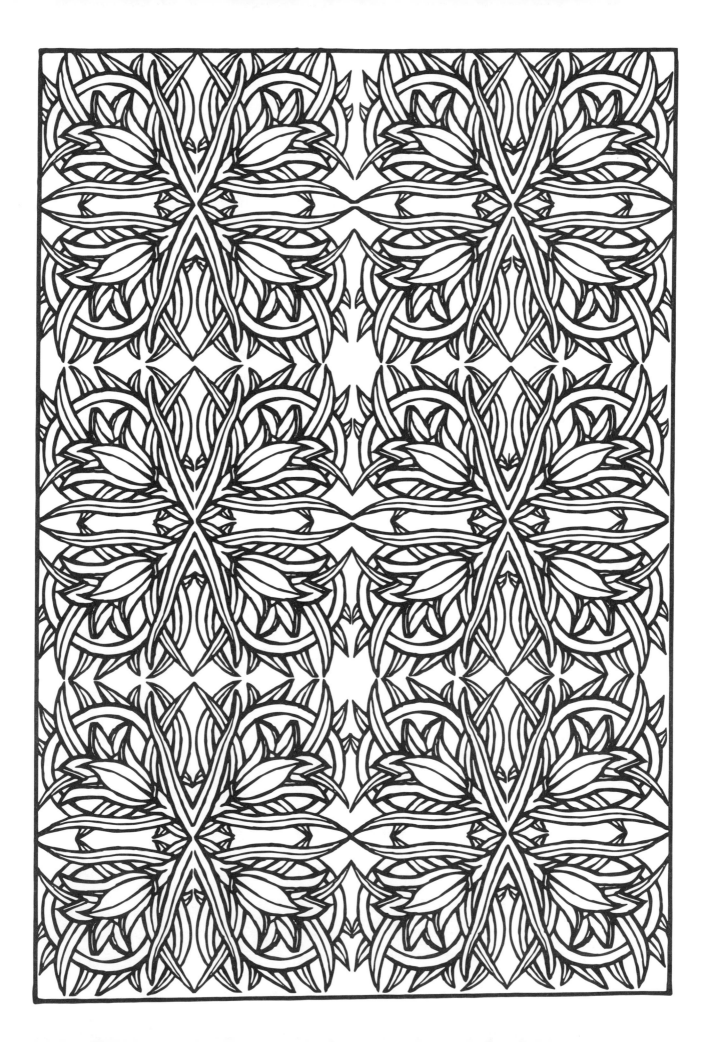

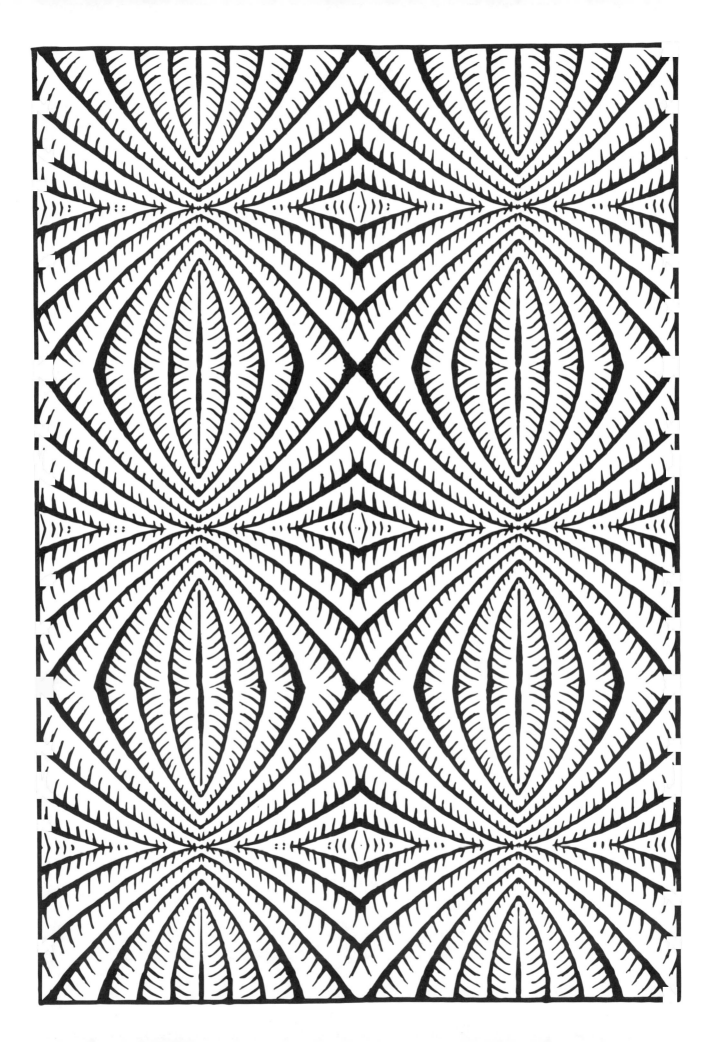

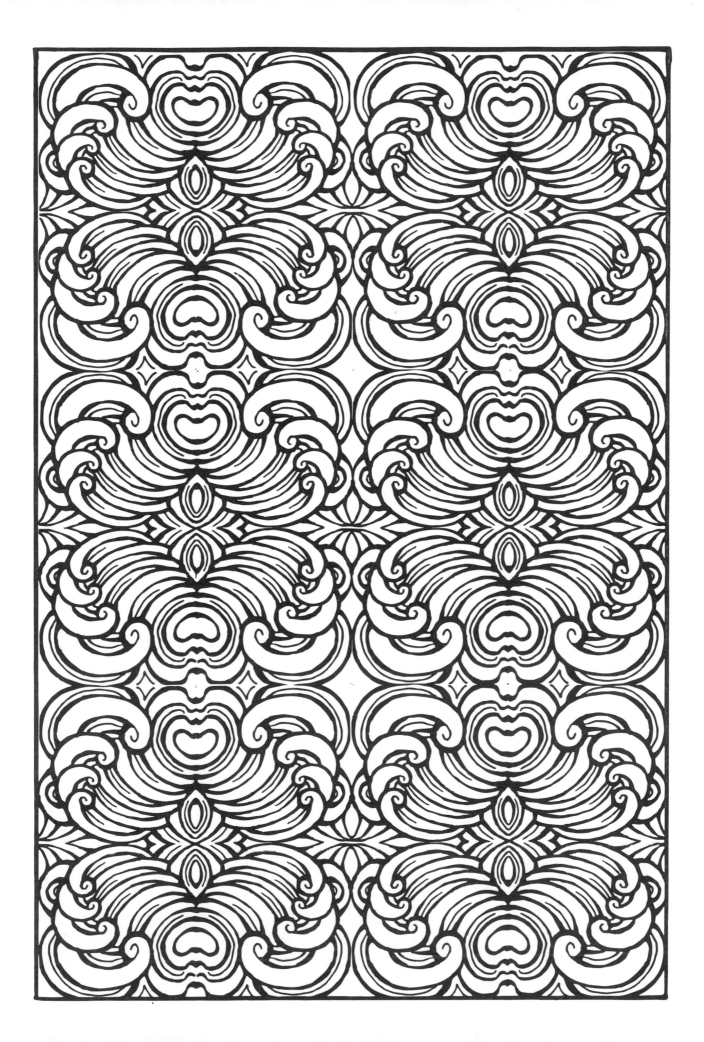

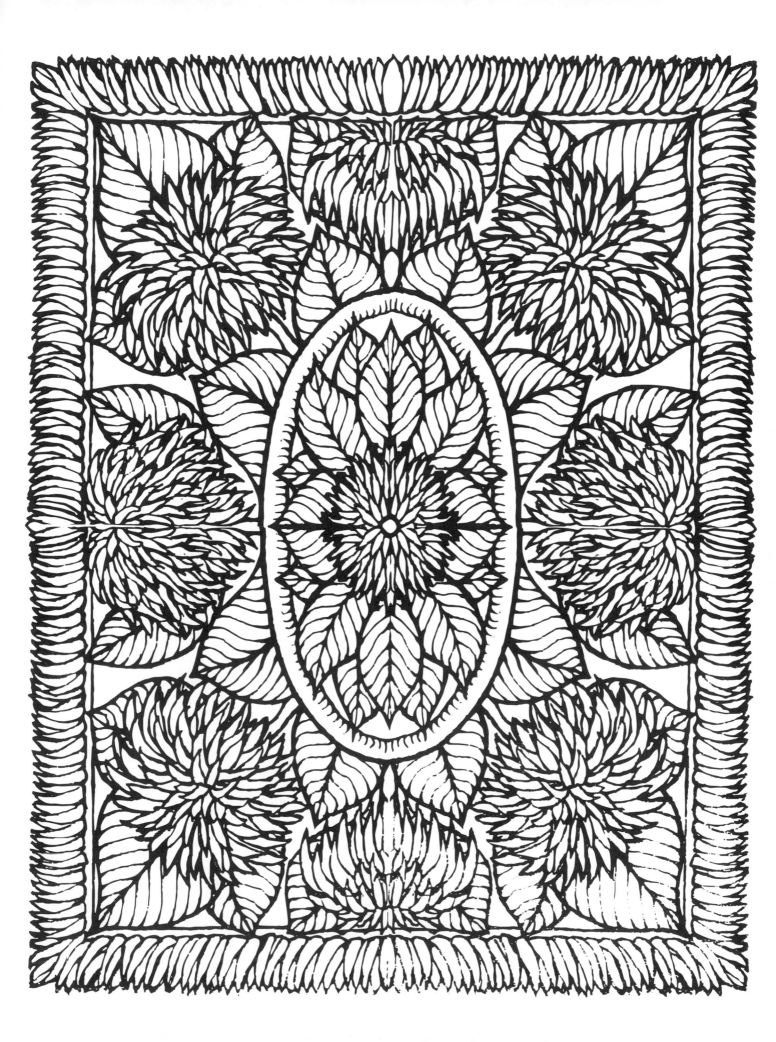

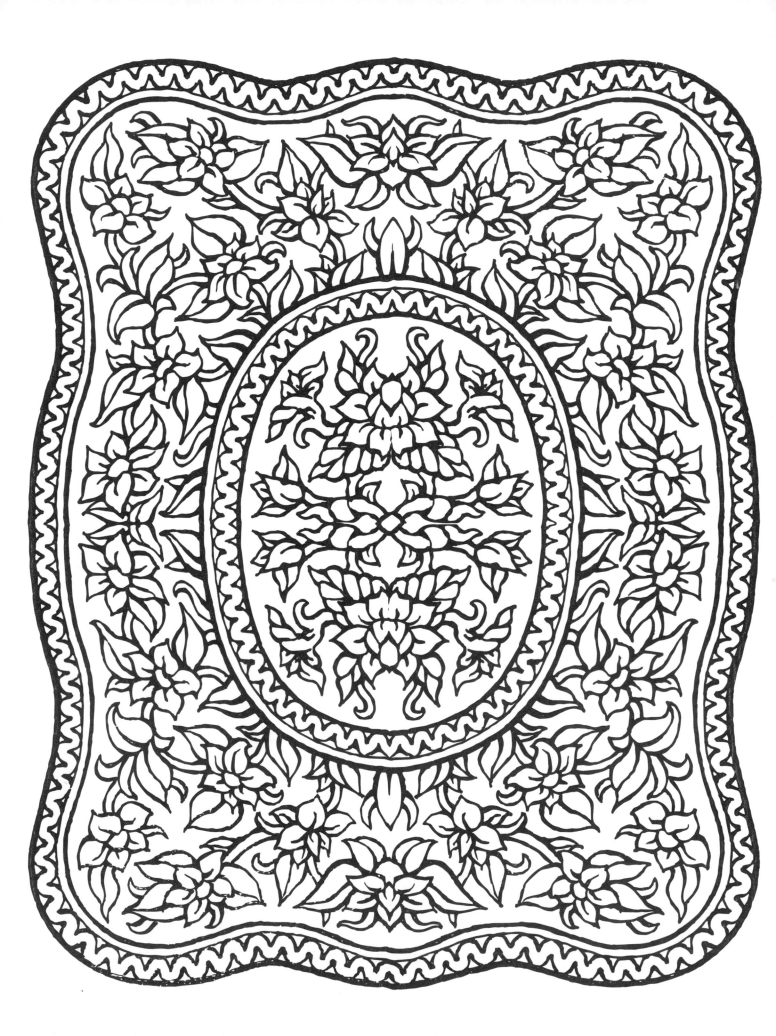

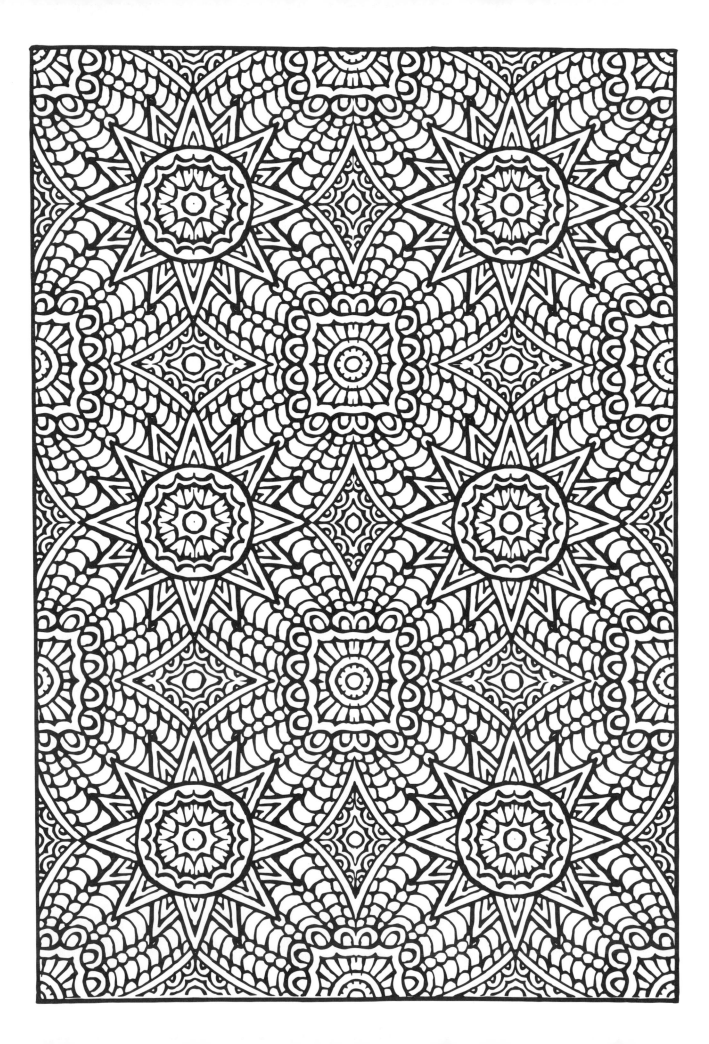

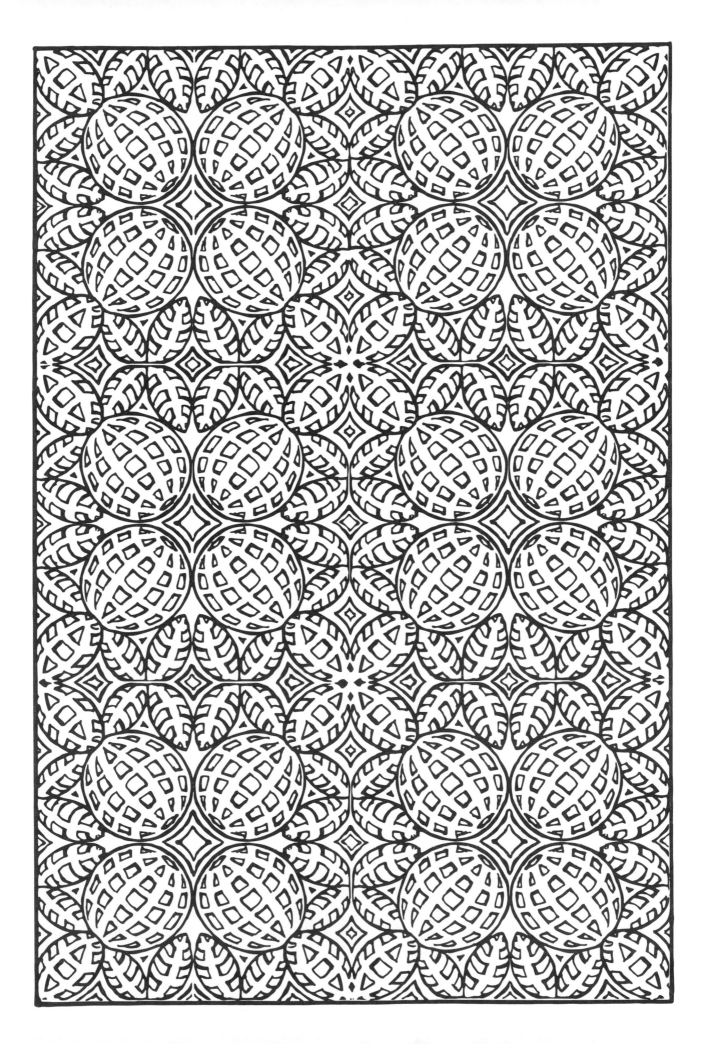

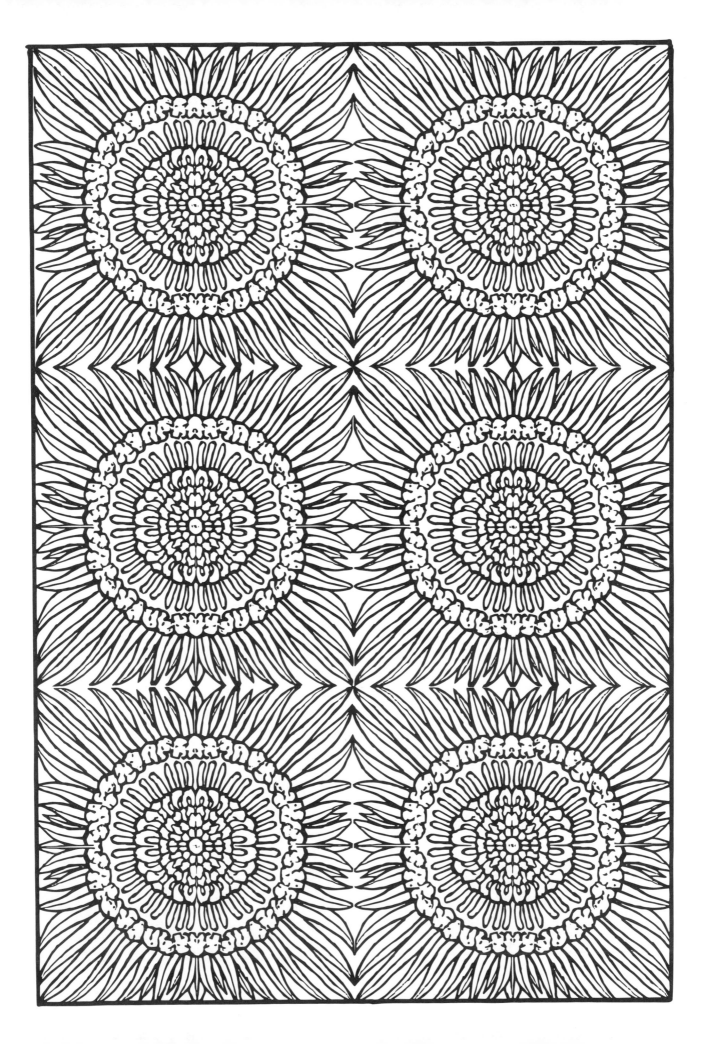

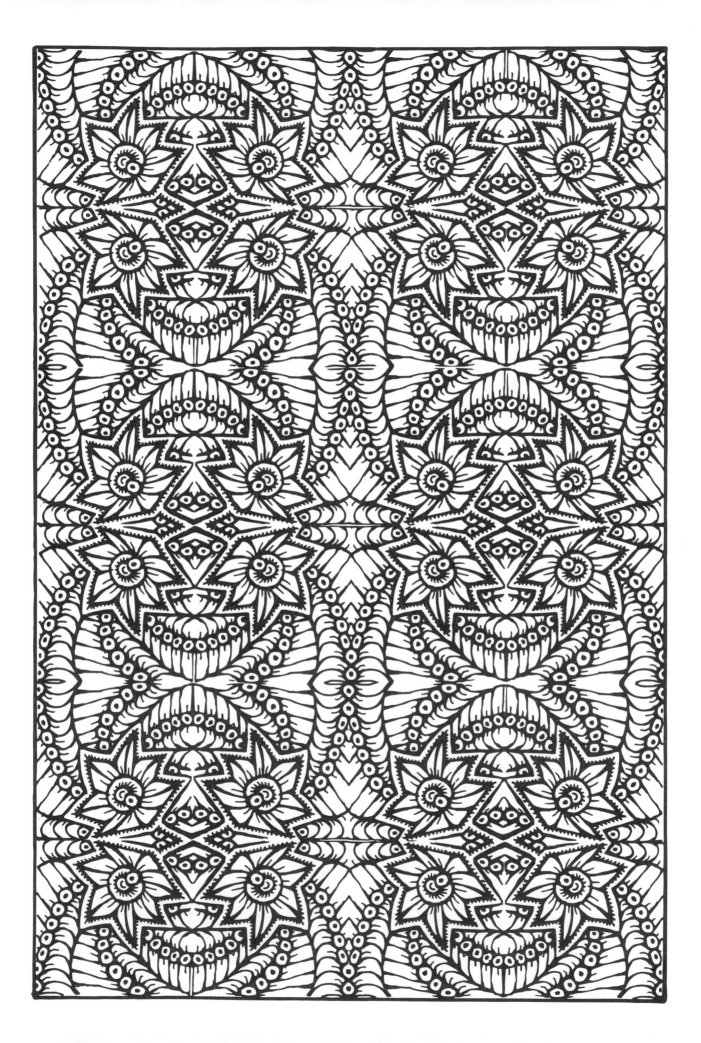

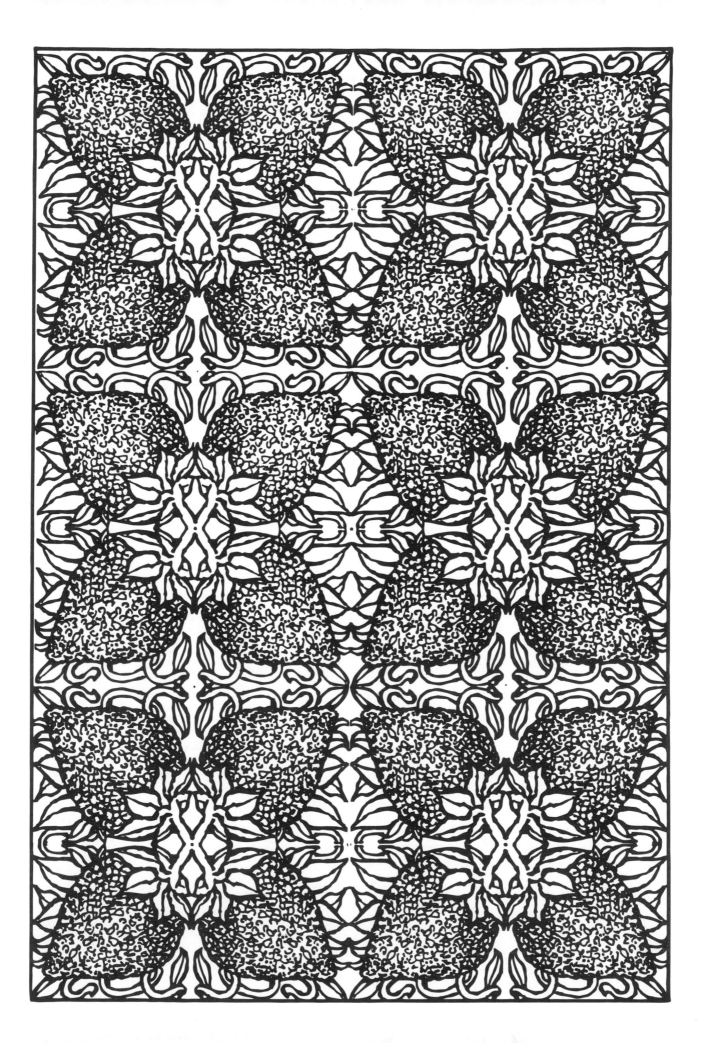

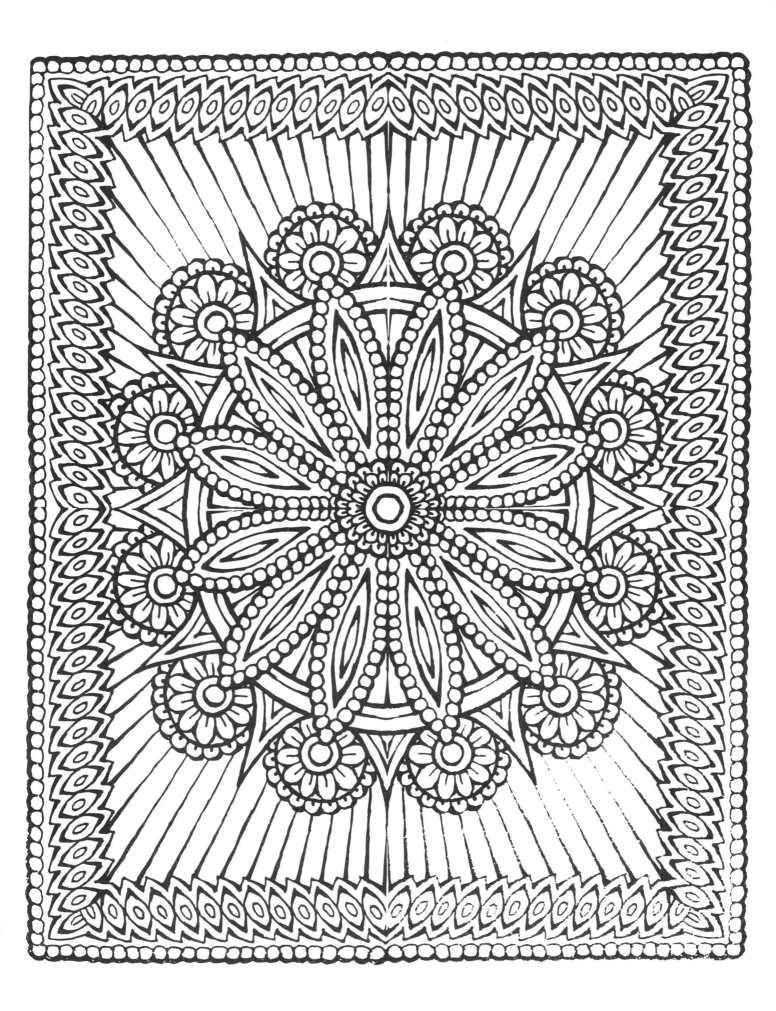

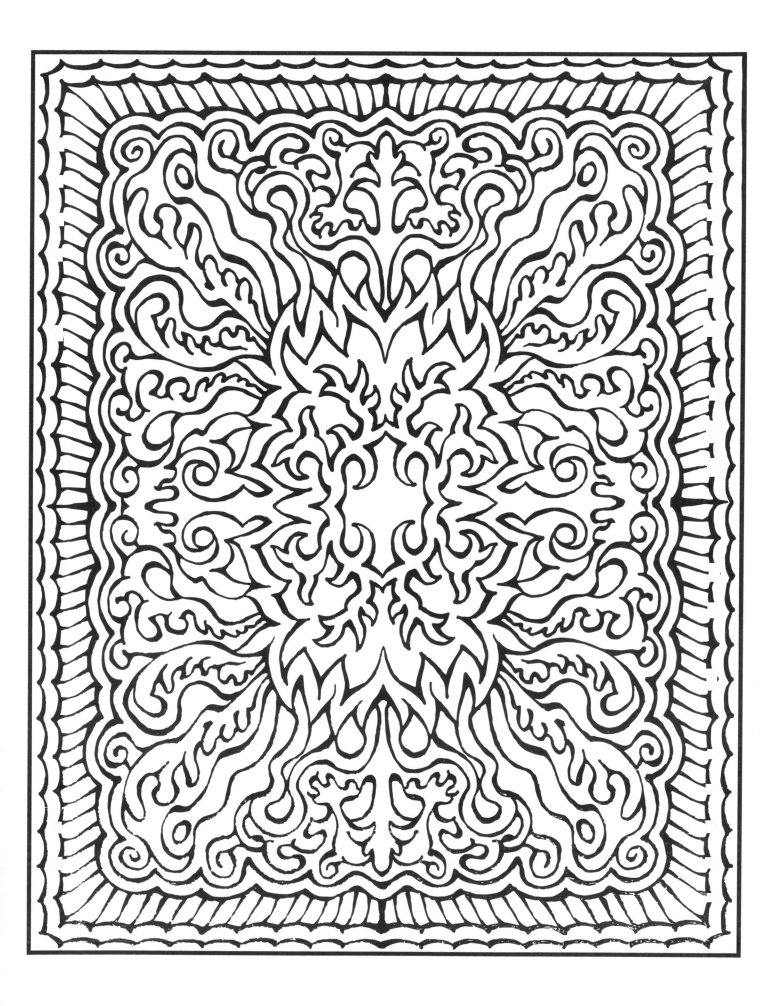

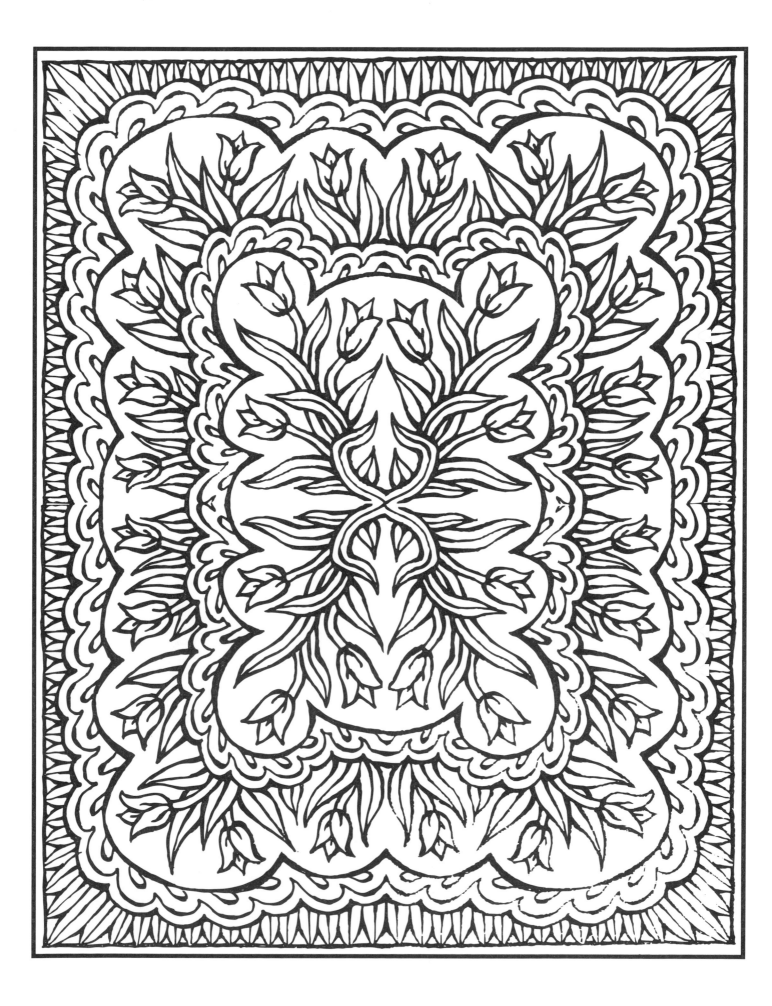

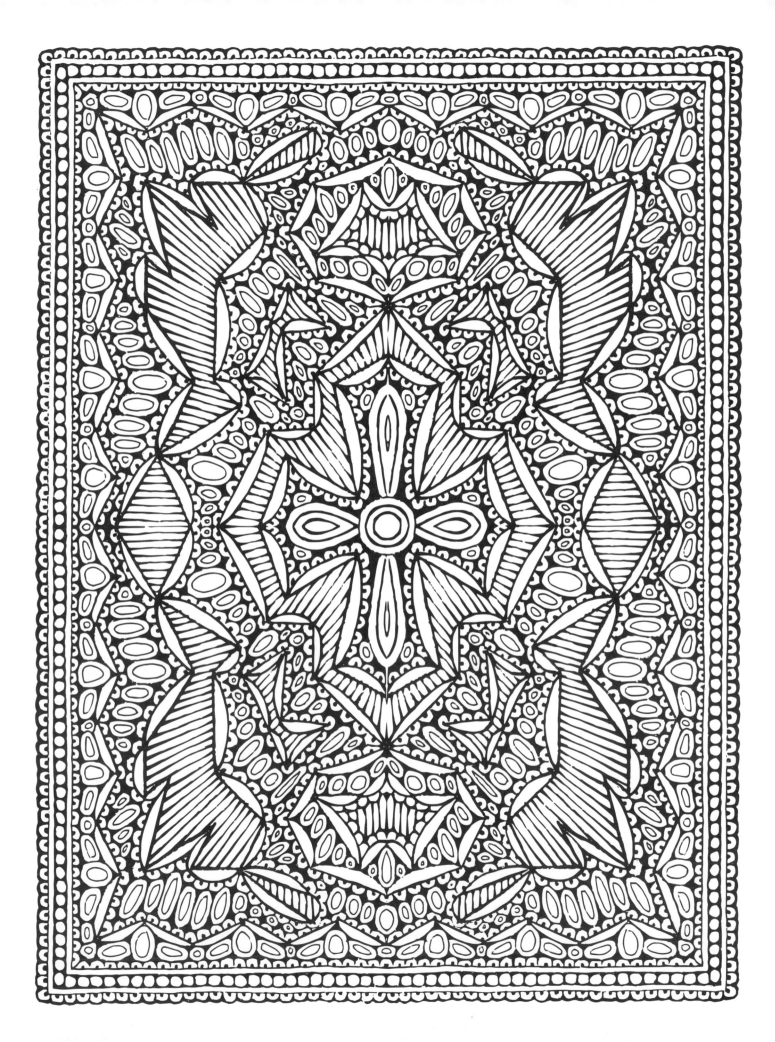

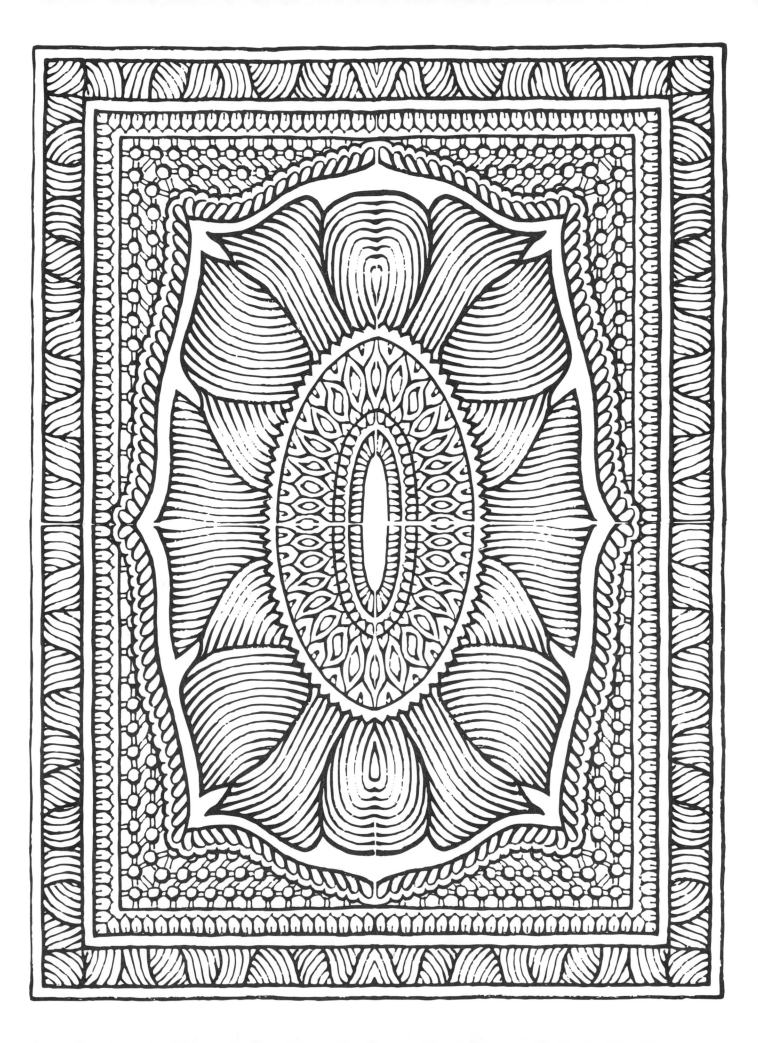

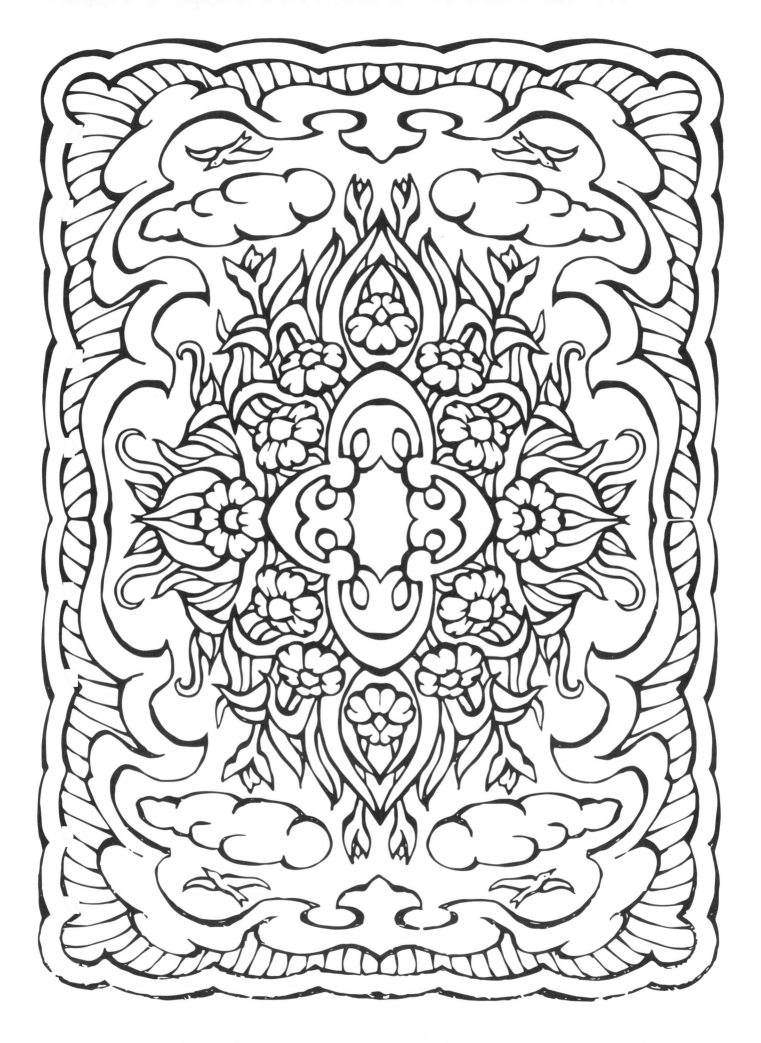

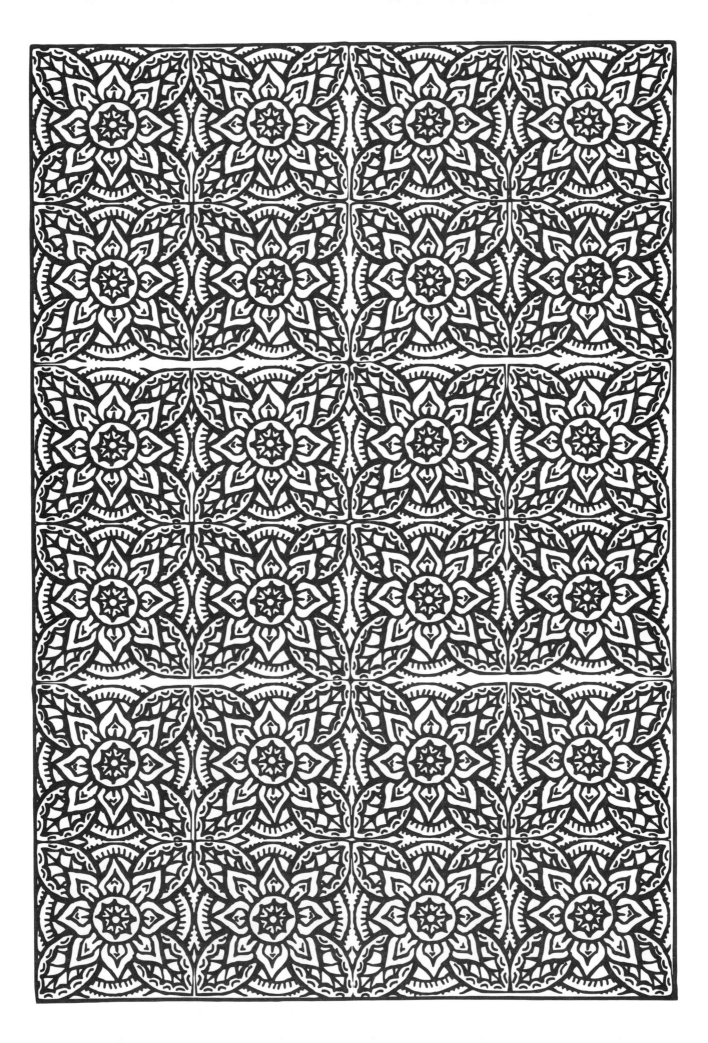

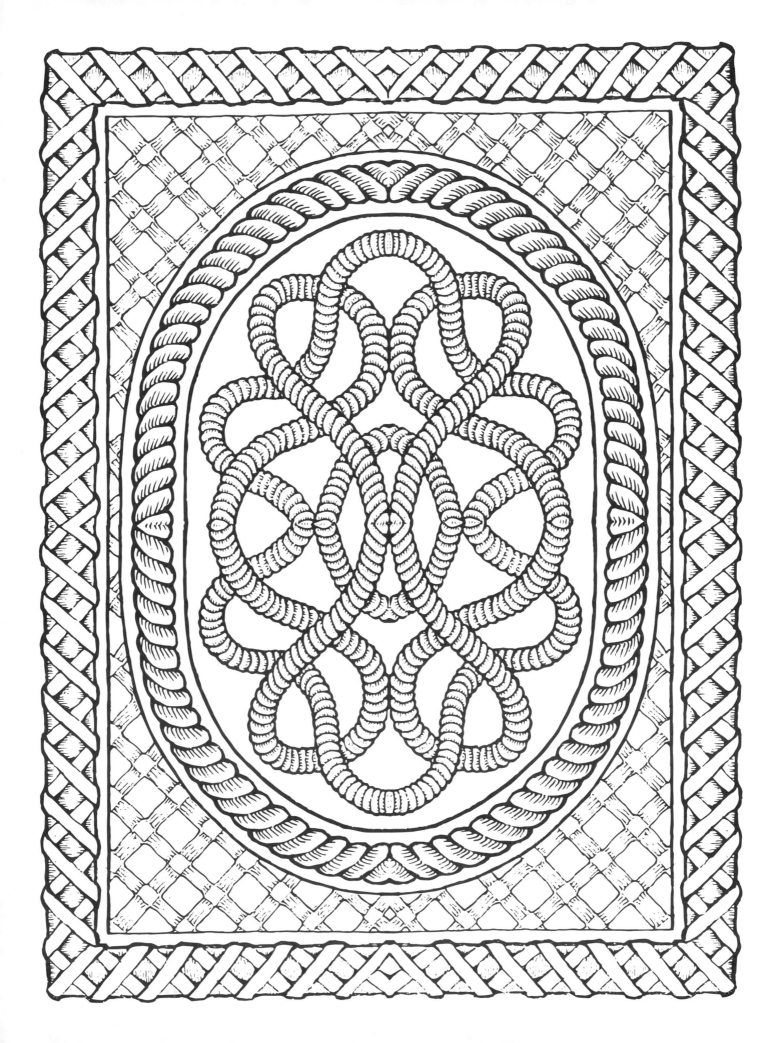

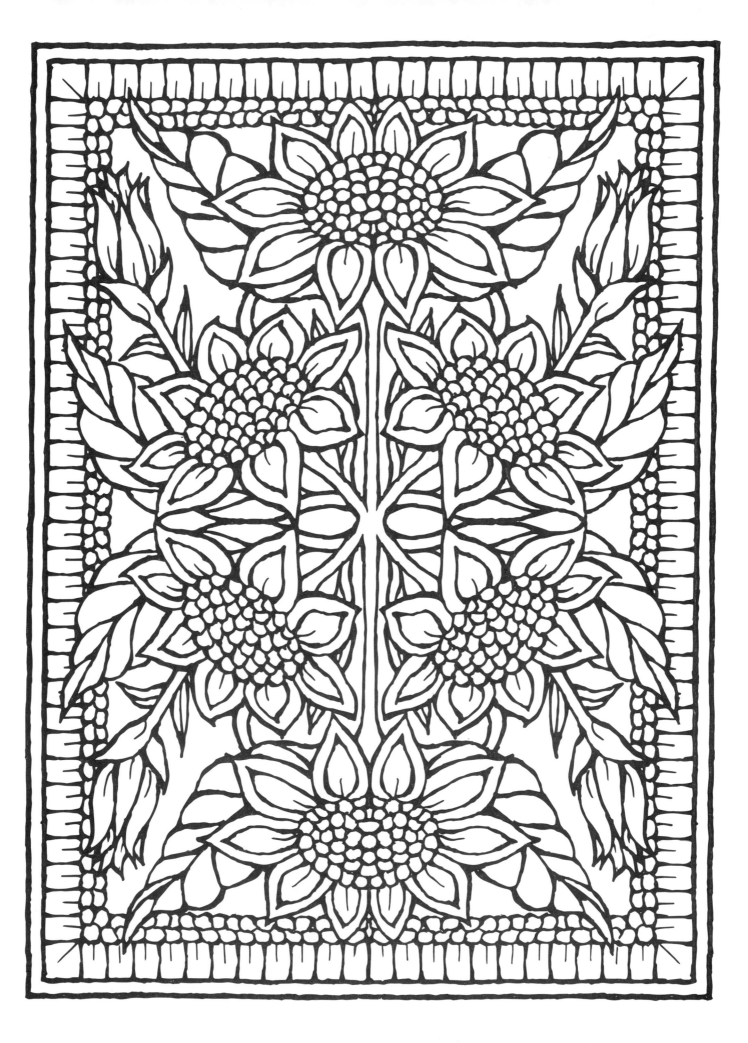

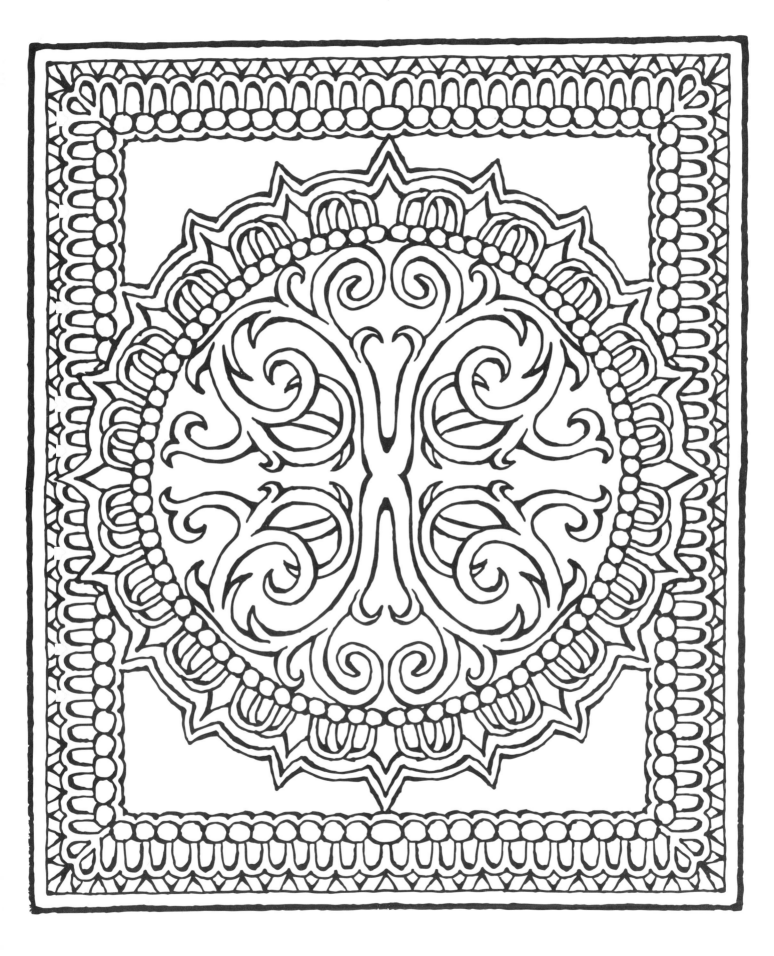

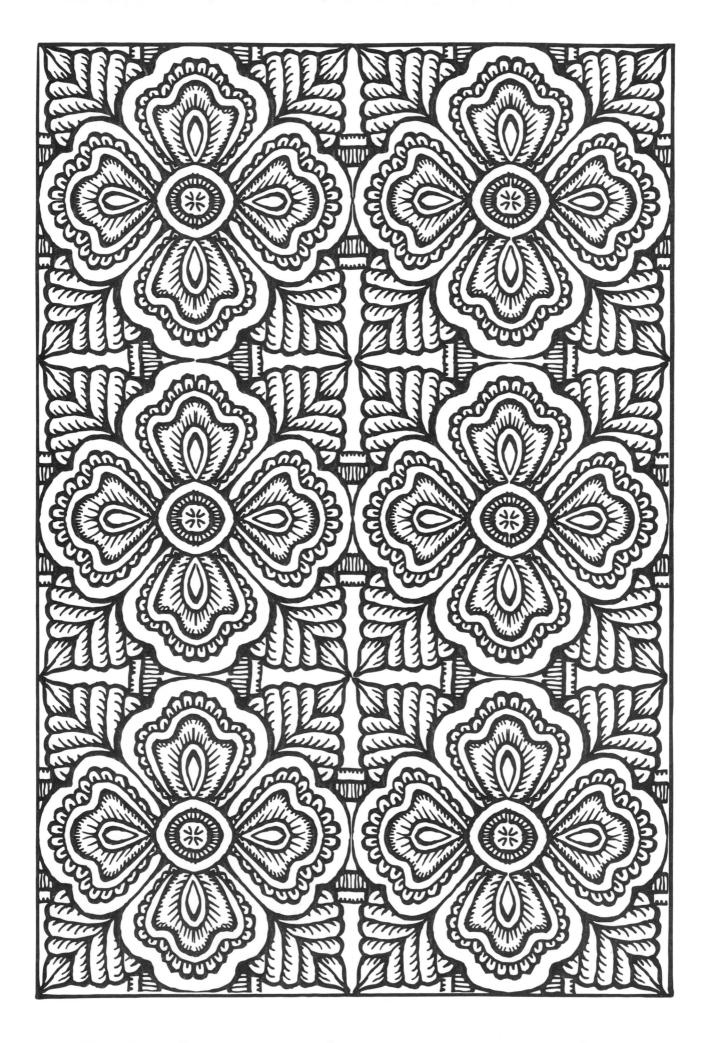

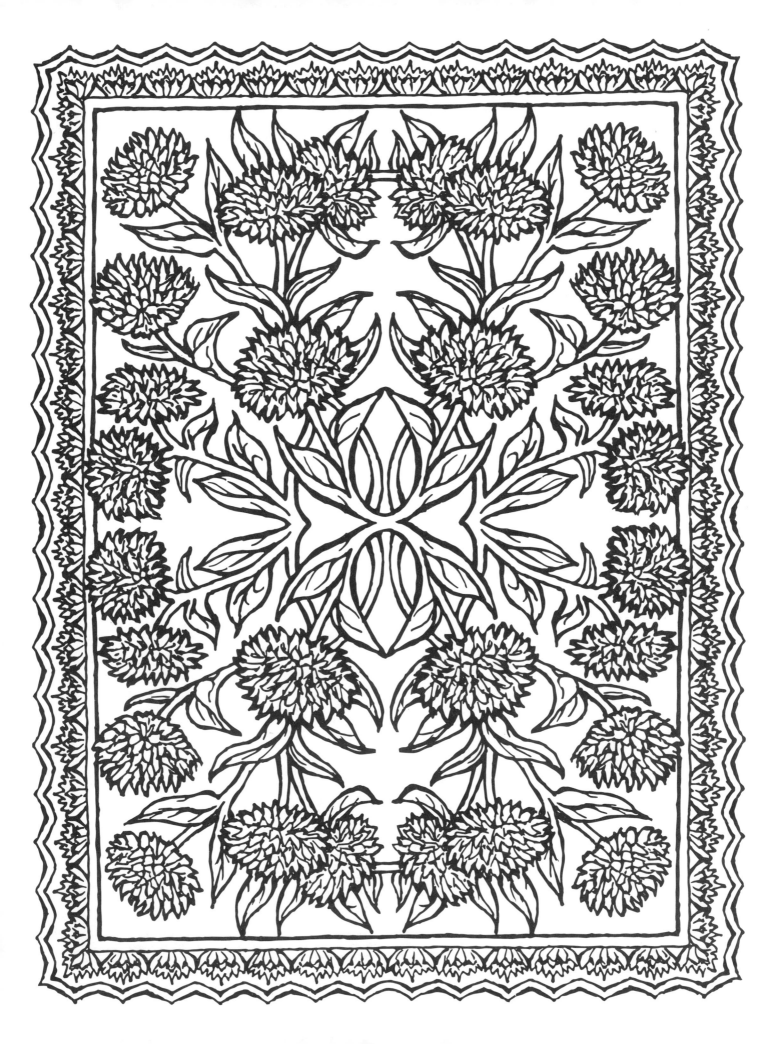

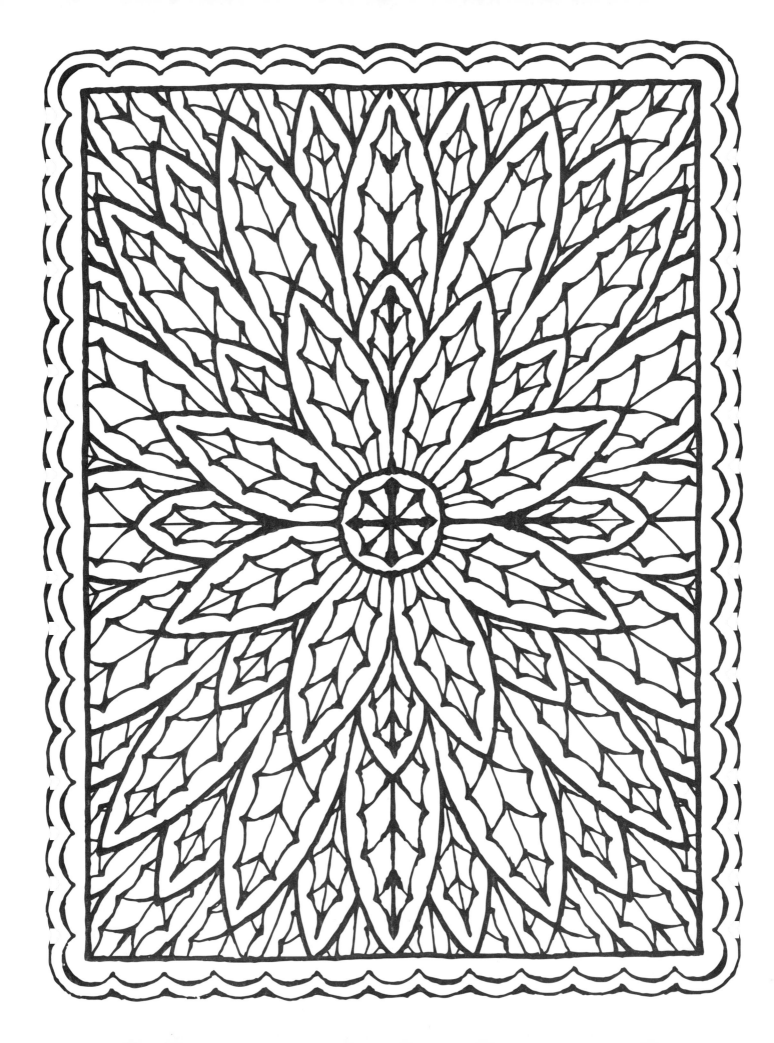

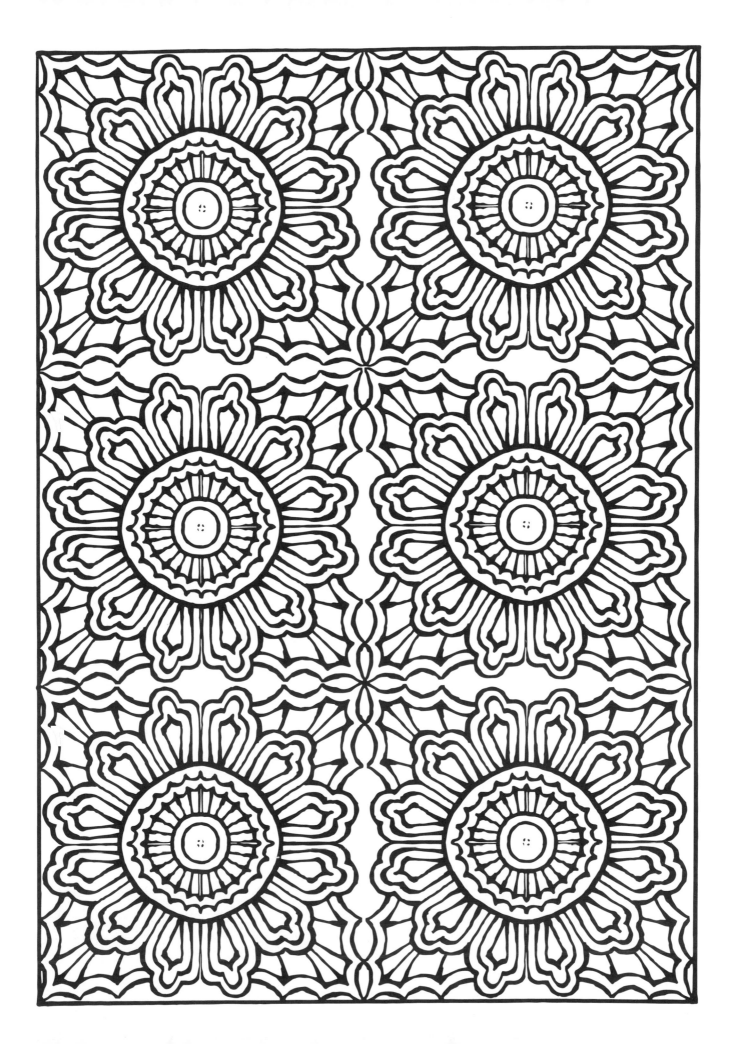

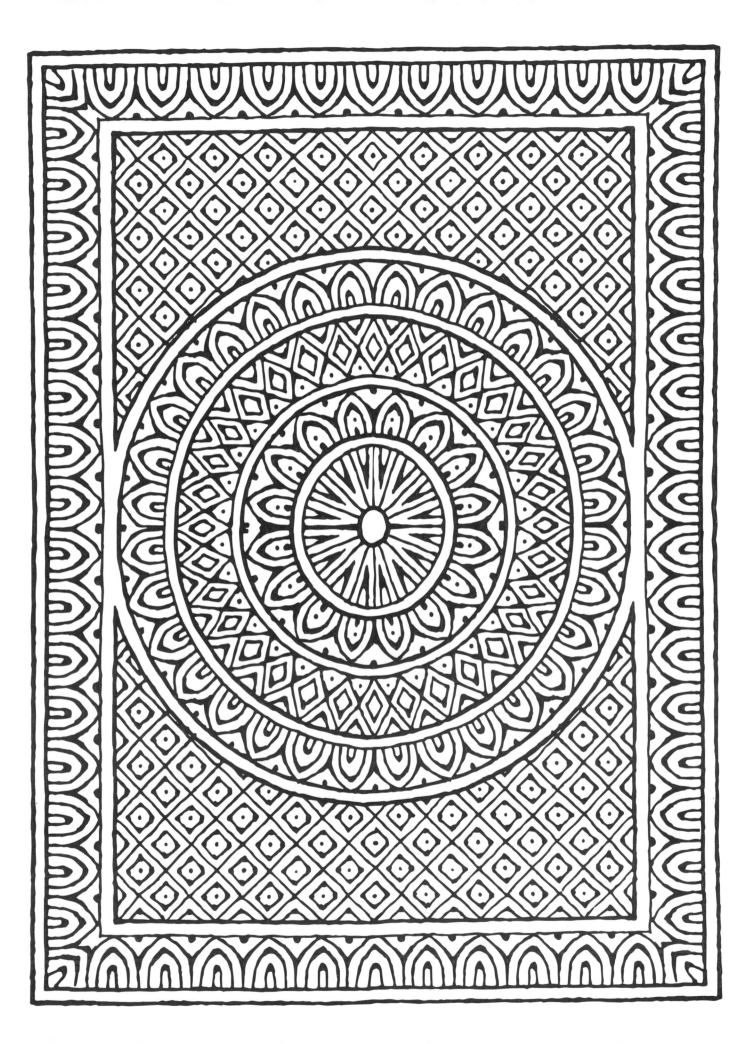

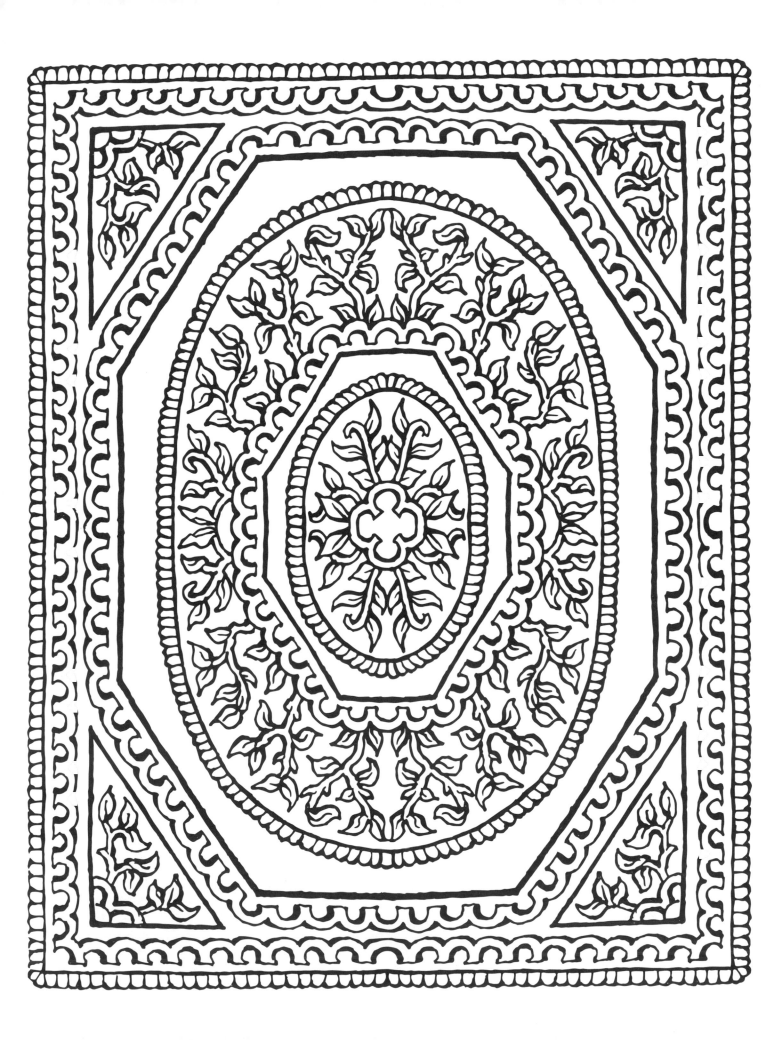

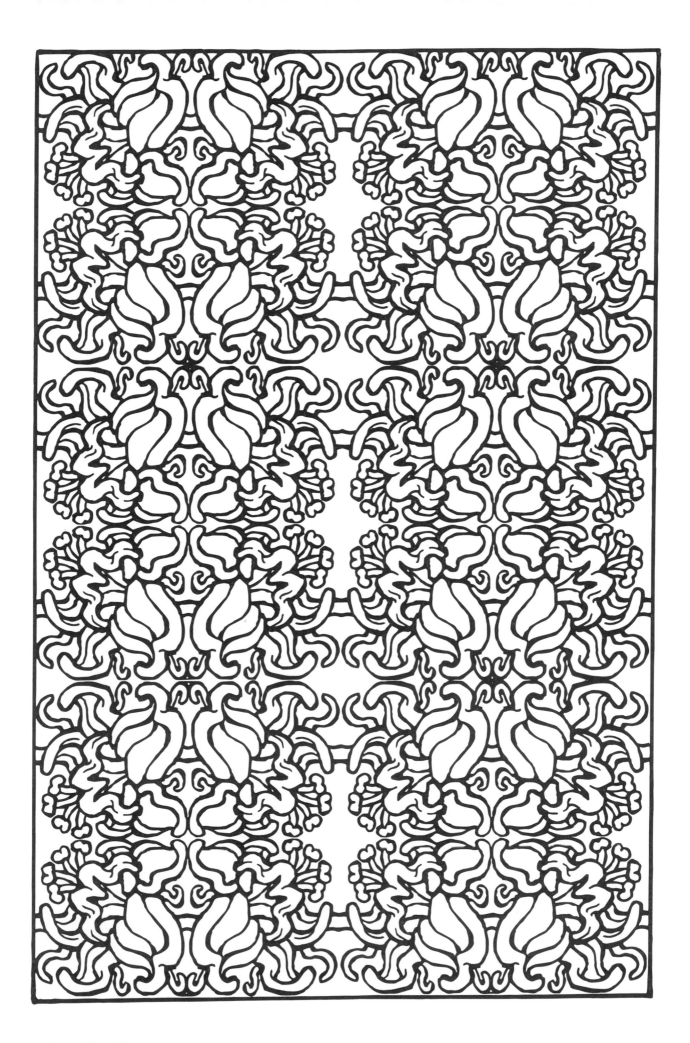

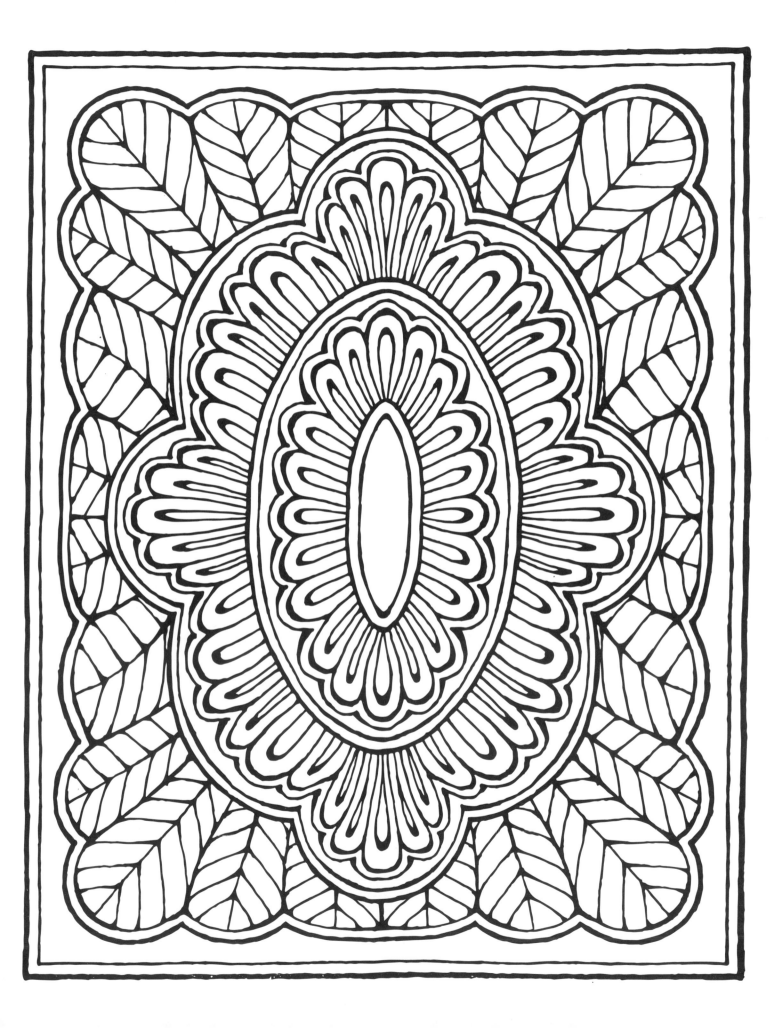

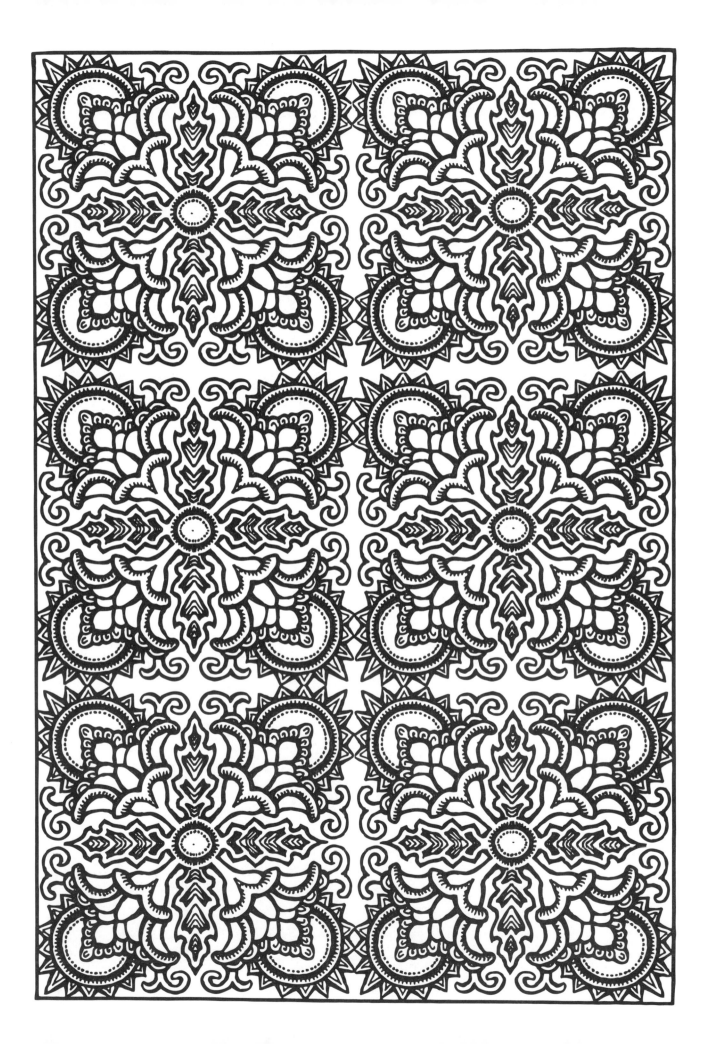

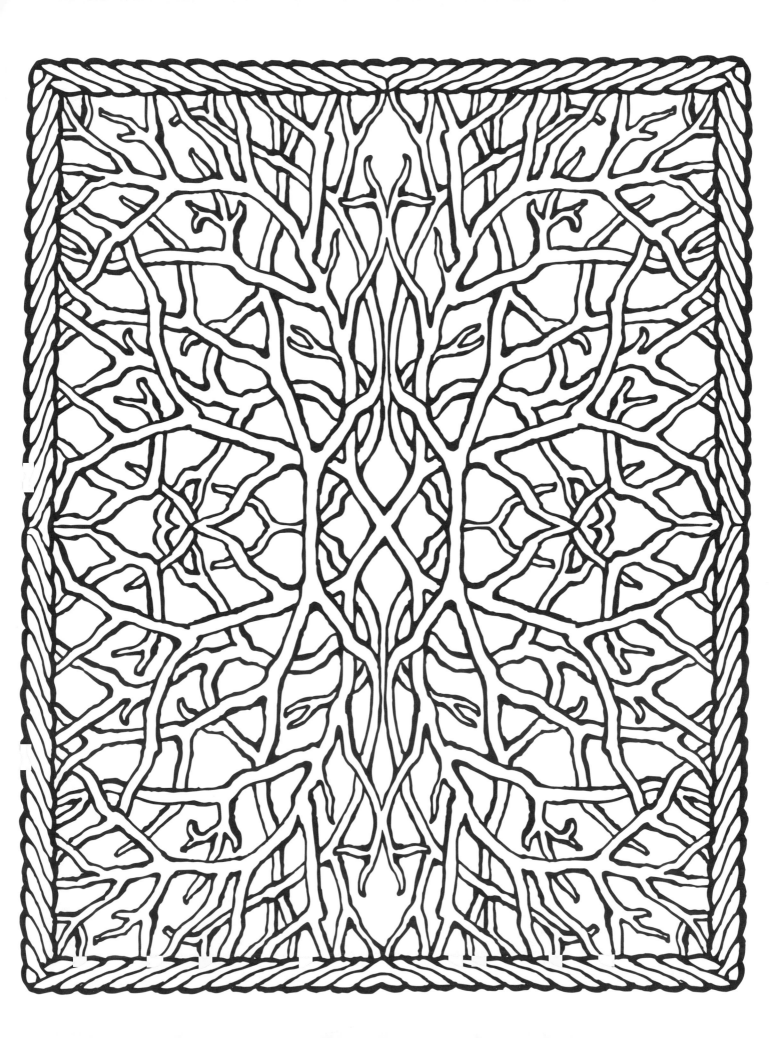

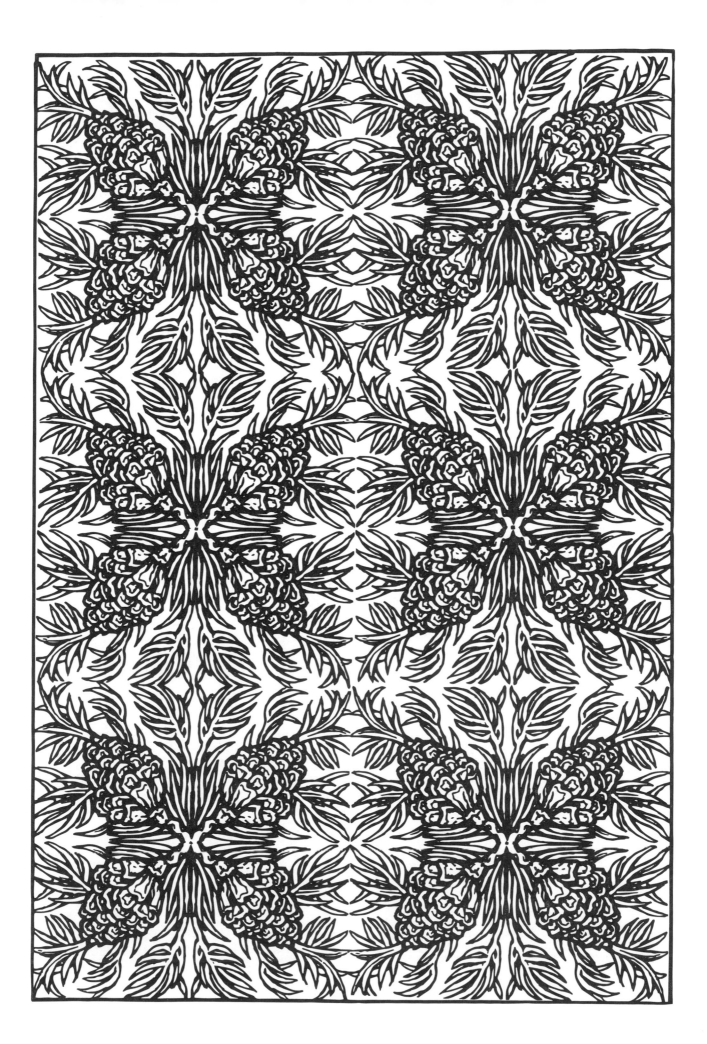

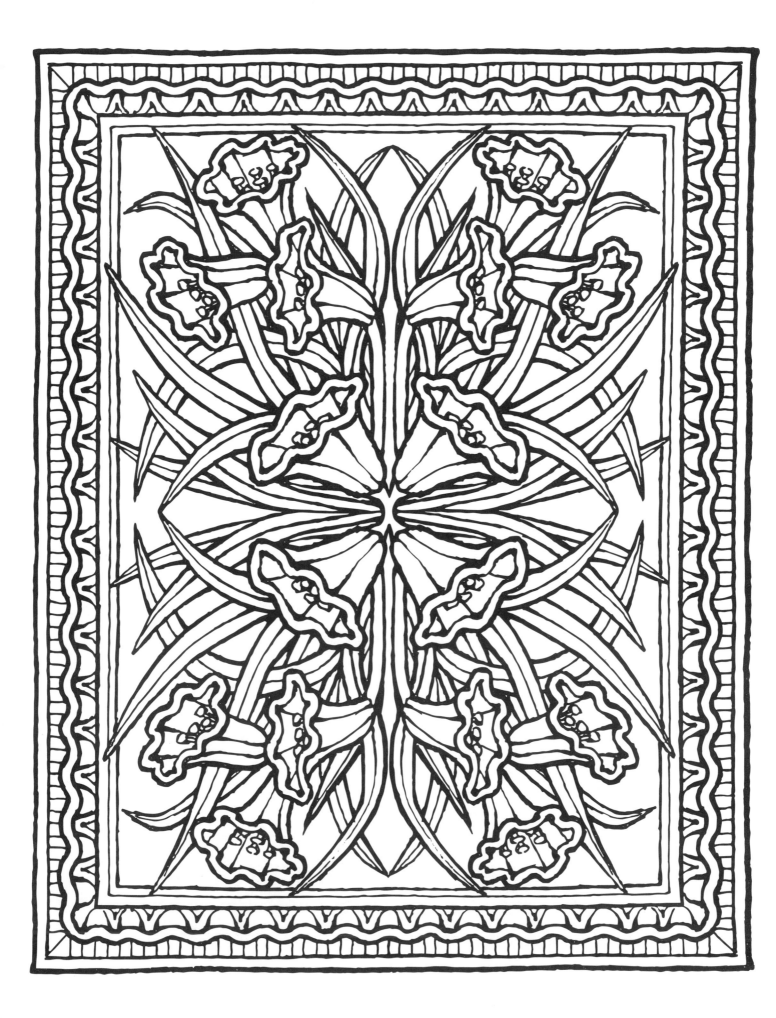

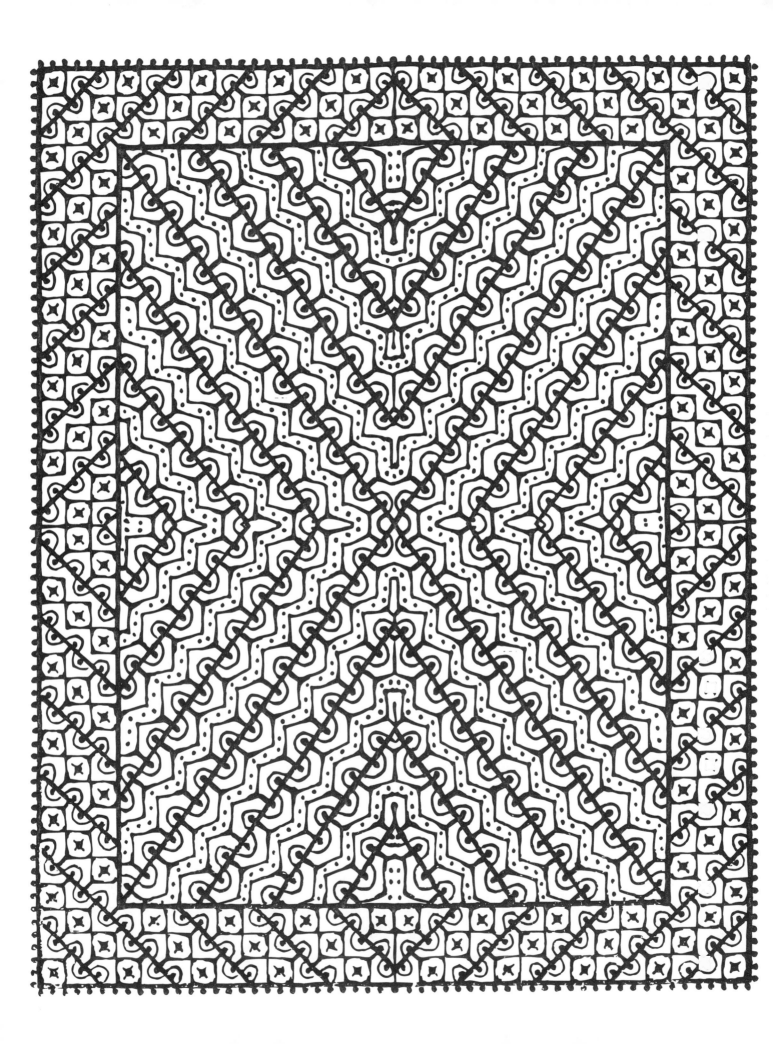

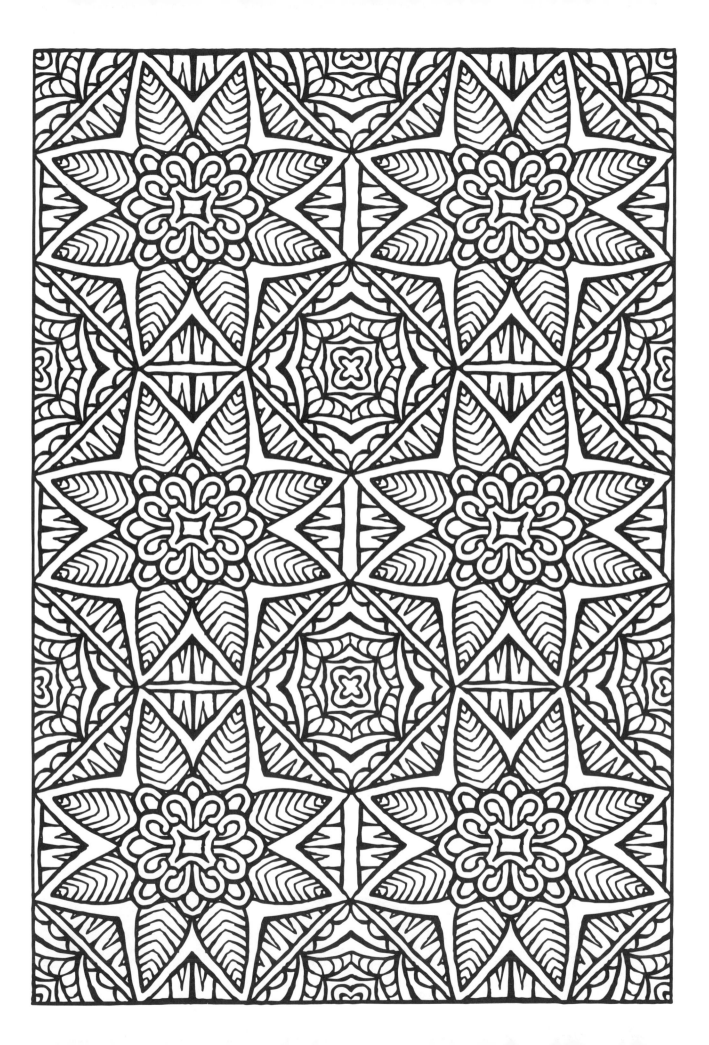

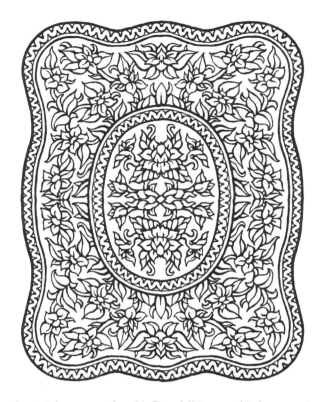

Zen is a tradition derived from the Mahayana school of Buddhism, which arose in Ancient China during the Tang Dynasty. It is often described as a philosophy that centers primarily around intense meditation in order to gain insight—where one carefully observes the breath and the mind to obtain complete and total focus. One of the main mantras of Zen is to let go of the past while not worrying about the future, to hone in on the present and be completely mindful of the now. The belief is that, by doing so, one will achieve inner peace.

The practice was brought to the United States in the nineteenth century by Japanese immigrants, after which interest only grew, particularly within the American art community. In today's stress-filled world, not surprisingly, Zen has exploded in popularity. With an obvious correlation to adult coloring and art therapy, Zen has emerged as a recent trend in the fields, providing many colorists with an aesthetic version of this stress-reducing practice through its soothing patterns, intricate designs, and easy access to mindfulness.

Designed by a bestselling illustrator and a master of the Zen style, *Alberta Hutchinson's Instant Zen Designs* will bring you peace and comfort as you focus on filling these beautiful patterns with color.

◦◦◦

Alberta Hutchinson is a master designer and colorist, as well as a notable artist of other media. In the course of her career she has created thousands of works, including coloring books, illustrated and design books, ornaments, quilts, and fabrics. She is particularly well-known for her elaborately designed borders, which frame many of her illustrations. Additionally, she has published more than thirty books, including a novel and poetry featuring her artwork. Most notably among Hutchinson's collection are her bestselling mandala and design coloring books, which delight colorists of all ages and levels of skill.

Also Available from Skyhorse Publishing